The Photography Workbook

The **Photography** Workbook

Lou Jacobs Jr.

AMPHOTO
American Photographic Book Publishing
An Imprint of Watson-Guptill Publications
New York, New York

Library of Congress Cataloging in Publication Data
Jacobs, Lou, Jr.
 The photography workbook.
 1. Photography. I. Title.
TR145.J32 770'.28 80-23391

ISBN 0-8174-5518-3 (softbound)

Manufactured in the United States of America

Other Books by Lou Jacobs, Jr.

Amphoto Guide to Lighting
Amphoto Guide to Selling Photographs:
 Rights and Rates
Konica Autoreflex Guide
The Konica Guide, Revised Edition
Olympus OM Camera Manual

Contents

Introduction

Maybe you've heard people say, "Photography is so easy; you just press the shutter button and the camera does the rest." I hope you disagreed.

Nothing is easy that challenges the visual and emotional senses—which photography does so well when you're into it. Therefore, the shallow person who cries, "too easy", is probably a happy snapper who points an automatic camera and lets the processors do the rest. Haphazard hobbyists do not deserve to be called photographers, because they're not much interested in *understanding* what really makes effective pictures. They're usually delighted if an image is merely "clear."

I am not against automation, but I do try to distinguish between the auto-dependents and the rest of us who learn technical controls, develop pictorial judgment, and do not expect auto-exposure systems to think for us.

If you plan to *read* this book and not just skim it, then you must also be planning to *work* at photographic problems, knowing you'll face occasional frustration. You also must sense that there is abundant satisfaction along the way to becoming a better photographer.

Following is a preview of what is in store for you, and what may be expected from you, in the *Photography Workbook*:

— Be prepared to experiment and struggle to master certain techniques that, once you "own" them, become second nature to use.

— Look forward to feeling more creative as your understanding of theory increases and your photographs improve. The reason is that you will be capturing on film more of what you visualized mentally as you looked through the viewfinder.

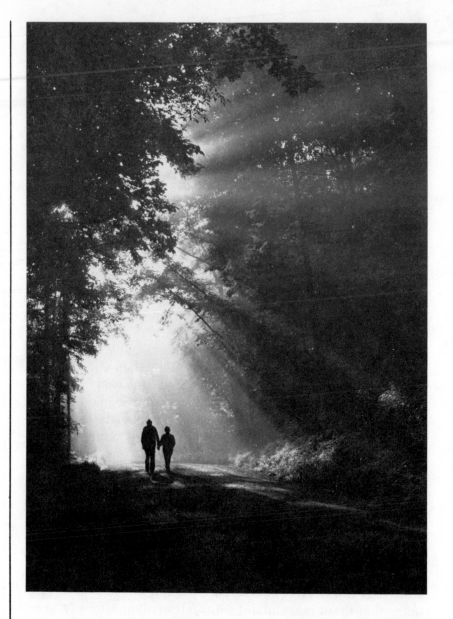

—Keep in mind that success at anything worthwhile is never instantaneous, and is not due to luck either. Remember luck is when preparation meets opportunity.

—Become involved in the *Workbook* projects. Your imagination is stretched, and you enjoy more beautiful, pleasing images, as well as the knowledge that you can do the same things again, sometimes better.

The *Photography Workbook* presumes that you will be persistent and will think positively. Photography is only easy to those who don't know the score. And the score is that you'll be distinctly ahead of the game at the end of this book.

Let's get started.

The Feedback System

This *Workbook* is designed to give you facts and opinions at the same time it stimulates your picture-taking ideas. The plan is that you read, respond, and follow through with a camera. Pictures have been chosen to challenge your abilities, for the pleasure of learning, as well as to let you enjoy the images you make. Hopefully, you will work through the problems in each chapter at your own pace. By shooting pictures, as prescribed, you are certain to gain more than if you only read about what to do. Your goals are: improving your technical skills and understanding, honing your imagination, and refining your resourcefulness. You will then be better able to find, or invent, worthwhile picture-taking projects for yourself.

The pictures throughout the book are similar to many types and subjects you may take, now or in the future. Many of the illustrations were taken to demonstrate a specific idea; others were selected to show you how nonprofessional people express their talent and enthusiasm with a camera. Still others were included to help you judge your work by what I call the *feedback system*.

FEEDBACK FACTS

One difficulty about trying to learn an art or craft from a book is the absence of someone to help you evaluate how you're doing—to give you some feedback. In a classroom, such comments come from teachers and other students; if you take a correspondence course, you hear from an instructor eventually. But people buy and read books, knowing that the pages won't stand up and talk, and they benefit by applying what they read to using a camera.

In other words, experience, experiment, and self-evaluation can help fill the feedback gap. This *Workbook* is planned

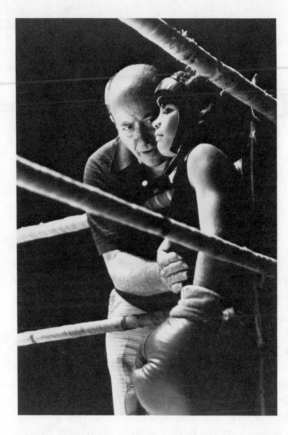

1-1. Sherree Brown grabbed Kodak's International Newspaper Snapshot Award (KINSA) winner at a boxing tournament in her hometown, Macon, Georgia. Judges admired the coach's expression contrasted to the youngster's face, plus the looming size of the boxing glove. "The photo couldn't have been stronger in color," they said.

to help keep you aware of how you're doing in terms of theory. You should be able to recognize your progress and where you need to improve. Feedback evolves from comparing pictures I've taken with pictures you take, from questions asked throughout, and from end-of-chapter exercises. You can expect to gain more confidence in handling cameras, lenses, and accessories, and to become more visually sensitive. Instinctively, you will take more care planning and shooting at home or on trips, and you should know with more perception what your mistakes are. In fact, you'll make more sophisticated mistakes!

Feedback requires your participation. You may sit, and read, and think, but as specific pictures and problems are discussed, you should begin to plan your own search for solutions. After you've taken your pictures, a return to the book should offer feedback and guidance to useful self-evaluation. You are not supposed to imitate the photographs in the book; rather, let them point the way to parallel shooting situations.

Feedback Examples

The system is based on your transposing comments about illustrations in the *Workbook* to photographs of your own.

Although many of the images are black-and-white, this should not handicap your shooting in color. The principles discussed relate to both color and black-and-white. For instance, photos 1-2 and 1-3 were printed from the same negative, the entire frame of which appears in 1-2. The people enjoying the surf south of San Francisco were photographed with an 80–200 mm zoom lens set at 200 mm, on Kodak Plus-X Pan film.

It should be evident how photo 1-3 was cropped or extracted. The vertical version represents another way of seeing and composing at the same location. How often do you shift your camera from horizontal to vertical, or vice versa? You may want to re-examine some of your slides and prints for a fresh approach to cropping; better yet, be more alert while taking pictures to exploit both format possibilities.

Photos 1-2 and 1-3 represent a typical comparison in the *Workbook* that is also valid in black-and-white or color. As you progress in the book, you'll make the conversion easily when necessary, and you may find yourself imagining the color as black-and-white when you get to Chapter 5.

Other Goals

The techniques discussed in the *Workbook* are common to most photographers, and the points emphasized are applicable to a large variety of subjects, from mountain lakes to children at play.

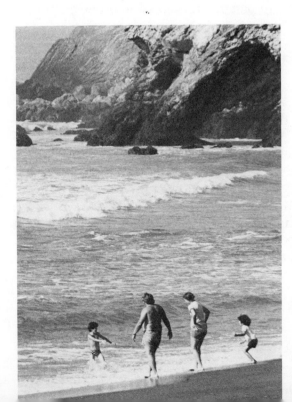

1-3. Vertical portion of photo 1-2.

1-2. Full-frame horizontal taken with 200 mm lens.

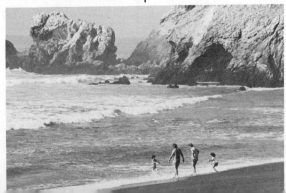

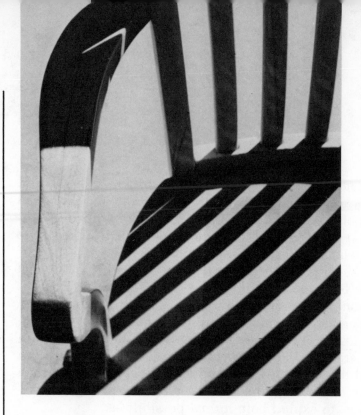

1-4. Diane M. Citelli won a Kodak/Scholastic Award with a simple, subjective (her high school teacher's chair) color photograph that translates well to black-and-white.

Another goal is that you will become aware of the skills you're gaining at each photographic opportunity. Fewer potentially good pictures will get away, and the whole effort will be more fun. If photography once seemed easy, it will appear difficult for a while, but using a camera will have more meaning. You will become less casual about picture-taking, but not so intensely serious that you get indigestion. You're one of the lucky people who can express yourself as you wish. Be glad you don't have to make a living shooting pictures according to someone else's whims.

To summarize, the *Workbook* aims to help you:
— Understand better what you're doing and why
— Realize why some pictures succeed and others fail
— Discover how to benefit from good and bad pictures

GETTING ACQUAINTED

Who You Are

I'm convinced that the readers of this book have a number of things in common. You are people who *care enough* to take photography courses and to read books. But while classes, teachers, and tutors can speed up learning time, they are not available to everyone. Besides, you are individuals who want to improve your abilities beyond the span of classes. In short, you're what I call *photographers in personal training*, and you make the most of books, along with other kinds of guidance. It is for *you* that the specific subjects discussed in this book were selected.

Photographers in personal training have many other interests, and from them, or related to them, comes the subject matter you enjoy shooting. You are *expected* to have an approach or style of your own, though it may not have surfaced yet. You may enjoy photography that is documentary, stagey, bizarre, or the kind that has no category. Whatever your preference, you are interested in seeing more sharply and shooting with more polished techniques.

What You'll Get

Personal training in the *Workbook* sense is mostly self-training; it is the most difficult kind, because there is rarely a mirror to reflect how you're doing. In other words, you have little feedback from other people. In a class or group you may hear, "That's a terrific sunset shot, but the beach is empty," or "What's all the junk behind the lady's head?" Such questions help you analyze your images. It takes energy and purpose to be objective with only a book for guidance. I know that, and this work is designed to help you over subjective barriers. At the same time, you should avoid being overly critical (sometimes a cop-out), and you'll learn when to pat yourself on the back for pictures well done.

1-5 and 1-6. Self-portraits are among the photo projects you can do without supervision, with no one to please but yourself. Seventeen-year-old Linda Foard used a 4" × 5" view camera for both these self-portraits. Photo 1-5 was taken with a wide-angle lens in color in her high school studio. Photo 1-6 was made on an overcast day in black-and-white. Two separate moods, two locations, and both pictures uncluttered. They were in a portfolio that won Linda a $2,000 scholarship from the Kodak/Scholastic contest.

"Good" and "bad" are relative terms, and seldom appear here. *Rigid* judgments are also out, for one man's "ordinary" is another man's "wow!" However, you need certain words, along with pictorial mirrors, for feedback purposes. You *feel* about your pictures or about images you see elsewhere, and eventually those impressions are expressed verbally. That's fine if you don't get tangled in words, or rationalize your regret over pictures that didn't work. Never underestimate the value of mistakes you can recognize; we're apt to learn more from the near-misses than the photographs we like immediately. The latter may make you complacent, while pictures that need improvement can motivate you to see more acutely.

To help free yourself from being reticent and to encourage personal expression, you will be persuaded to enjoy a dialogue with yourself about your own pictures, as well as those made by other people. You will discover more about being judgmental as long as you give and take in search of improvement. You won't have to search for where and how this happens, because examples are incorporated throughout the book.

PREVIEW

Each chapter is designed to deal with subjects and solutions that have a high priority to serious photo enthusiasts. Here's a preview:

Equipment. Cameras, lenses, and accessories make it all happen, but are not the most fascinating items in your photographic life. Equipment must work for you without distracting or seducing you.

Depth of field. This basic topic is puzzling to many people until they discover how really elementary the principles are. Depth of field is an optical phenomenon that you make into a positive force.

Composition. There are dozens of ways to compose a picture from a viewpoint that may be personal, formal, interpretive, or intentionally obscure. When you know the guidelines, you're free to be subjective or conventional.

Color. There's realistic, impressionistic, and distorted color in slides and prints, which you can accomplish on purpose or by accident. You should know the difference, as well as the practical, artistic, and emotional qualities of color.

Action. Too much sharpness can be an obsession, and a little blur can be a beautiful thing. We'll discuss both, along with peak action as it relates to visual impact.

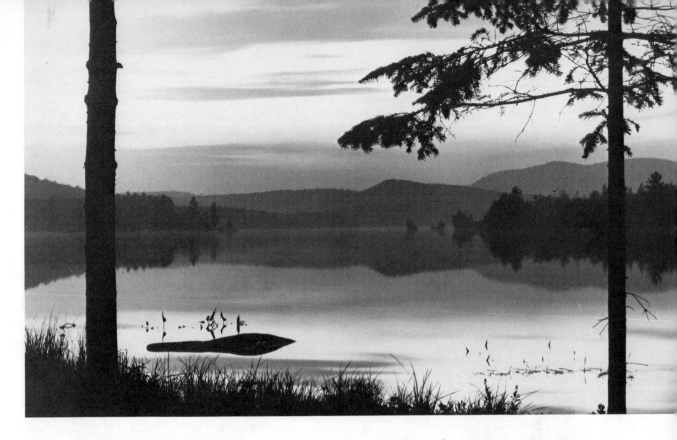

Available light and after dark. Many camera owners are inhibited at night because of the so-called risks of poor exposure. We'll investigate the afraid-of-the-dark syndrome along with those occasions when 1/30 sec. at $f/2.8$ is better than using flash.

AT YOUR OWN PACE

Leaf through the book and stop wherever you're inclined, or read it in sequence. However you wish to get involved is your choice. Remember: It's more valuable to you to mix reading and picture-taking. Projects and picture problems are suggested, and you will modify them to suit your own circumstances. There is consolation in that no one is looking over your shoulder, unless you ask for feedback from someone whose judgment and tact you trust. In self-training, expectations and what you do are mostly from individual initiative. You need discipline, but at your own pace. The feelings of satisfaction are worth it.

The Lucky Majority

This *Workbook* is not for professional photographers, some of whom feel they know more than they do. My aim is not to help someone make a living with a camera, though I have written often on that subject.

Rather, *Photography Workbook* is for the lucky majority who have themselves to please first. Other people may offer opinions about your prints or slides, but you can accept or reject at will. As a fortunate nonprofessional, you may shoot in

17

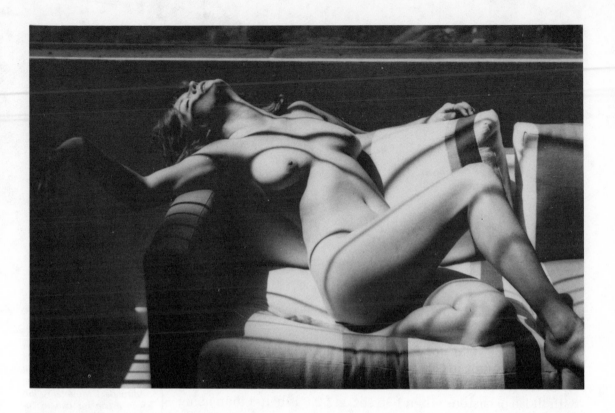

1-8. An experimental nude by the author, shot with sunlight coming through slotted blinds. The model blends with the background, but the forms together are synergistic.

any style or location that pleases you. You have no deadlines to worry about, nor will anyone fire you for not making images they've ordered. For you, photography is personal, and triumph over frustration can be part of the pleasure.

About the Author

I've been an amateur and a professional photographer for over 40 years, but my enthusiasm has not dimmed. Taking pictures has occasionally been a chore, but no more. For some years now I've been having fun with a camera, experimenting and realizing that creativity comes from inside forces responding to outside stimuli. The joy of personal expression with cameras and in the darkroom gives me the urge to do well and to persevere.

On the wall near my desk are two sayings which invigorate me. The first one states, "Rediscover photography from day to day." The second, attributed to Edward R. Murrow, states: "The obscure we see immediately; the easily apparent takes longer." Photography is an adventure. It is an individual way of seeing the world and making decisive or visually fulfilling moments your own. As a member of the lucky majority, I welcome your company in exploring for the obscure as well as all that seems so easy to see.

Exercises

1. Descriptive words applied to photographic images may excite your visual imagination. Using some of the words that follow, write down your impressions and evaluations of pictures you've taken or seen. If that seems too specific, use the words to discuss photographs in general, abstractly or practically. Ask yourself such questions as: Have I ever done what might be called an intimate portrait? Am I timid? Is the sensual tough to contemplate? As another alternative, you can define, in visual terms, some of the words that have meaning for you. *Then consult the dictionary if you wish.*

adventurous	exciting	pictorial
amateur	fragile	pretentious
beautiful	impact	reality
bizarre	impressionistic	rewarding
contrived	interesting	rigid
creative	intimate	satisfying
delightful	mundane	sensual
disappointing	mysterious	static
dynamic	obscure	stimulating
entertaining	ordinary	timid
erotic	original	valid

2. Describe several ways in which you hope to get more fun
 from photography. For instance, would a trip downtown
 on Sunday or a color essay on an outdoor market turn you
 on as photo projects?

3. Name a few people whose pictures you admire; they may
 be well known, or familiar only to a limited circle. De-
 scribe briefly *why* certain images by these favorite people
 stimulate you.

4. Make two separate lists, as long or short as you wish. On
 the first list, write the things you do best or know best
 about photography. Example: I have a good sense of tim-
 ing. I can recognize why a slide is exposed poorly.

On the second list, write some of the things you'd like to improve in your technique, or learn more about. Example: I'm not clear about sequence photography. Composing fast pictures baffles me.

Note: If you need more space, add your own pages. An advantage of making your notes here in the *Workbook* is that you have the material handy for future reference. You may be surprised how what you write today will appear to you a year from now.

Joys and Follies of Equipment

Photographic equipment can be a distraction to concentrating on picture-taking. Modern cameras and lenses are beautiful to look at, and when they're also expensive with a highly touted brand name, some people tend to treat them as status symbols rather than as useful tools. Some cameras and lenses are better than others in optical, electronic, or mechanical quality, but rarely will you find a lens that isn't sharp, or a camera body that breaks down regularly. In this day and age, companies that once made inferior products are no longer in business. Therefore, you can save money on cameras and lenses, if you won't be self-conscious about not owning a glamorous name. I've had students with big-name cameras and students with discontinued, obscure models; yet there was no way to tell who had what equipment by looking at their pictures.

CAMERAS

110 and 35 mm Types

There are now a few 110-size camera systems with either zoom or interchangeable lenses, but people who use this small-size negative or slide are limited in their photographic *control*. Control means being in full charge of focus, exposure, lens changes, automation, and even the extent of image enlargement. Thus, to suitably work on techniques involving depth of field, composition (110 finders are smaller than 35 mm finders), sequence action, and other things, you'll do better with a 35 mm or larger camera. However, if you own a 110-size camera and love it, read on and apply what you wish.

Among 35 mm cameras are many compact models with nonremovable lenses, some with built-in flash, and all with

2-1. Here's another KINSA winner, snapped by a fellow firefighter, Robert W. Foor, as a group of recruits trained to fight air-crash and fuel-spill fires. The original is in color, but it translates handsomely to black-and-white. Foor's camera is not mentioned in the Kodak caption, but the format and subject almost guarantee that he used a 35 mm SLR.

automatic exposure capability. Most are well made and worth the money, but think of these as second cameras, when you want something handy in your pocket or purse. Why? Again, because you do not have enough controls over lens focal length, exposure, and the like.

35 mm SLR cameras. Much has been written about this most popular mode of picture-taking. The 35 mm single-lens reflex (SLR) is an ideal tool for learning and for self-expression. Viewing through the lens offers useful control over focus and composition; and built-in exposure metering, whether automatic or not, is also a big plus. With the large number of lens focal lengths and accessories available for SLR cameras, there is very little you cannot do with this equipment. Therefore, the *Workbook* will emphasize using a 35 mm SLR, though a larger SLR format offers similar possibilities.

Today's 35 mm SLR cameras are available in a bewildering number of models and exposure systems. Study brochures, consider your needs, make a choice, and ignore the rest. As for automation, it's here to stay, it works beautifully, and manual exposure-setting cameras will eventually be found only in museum exhibit cases. Many of my professional colleagues who used to shake their heads in amazement to see

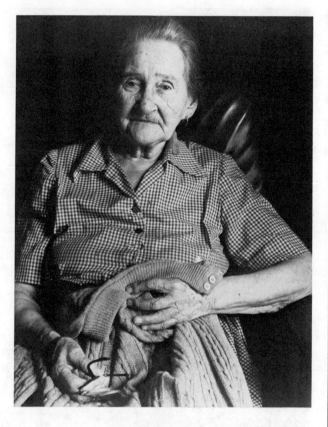

2-2. Though built-in exposure meters and automatic exposure systems are popular and convenient, Victor Miesel won a Kodak/Scholastic Award for this revealing portrait of his 90-year-old grandmother using a 2 1/4″ × 2 3/4″ format camera and a handheld exposure meter. People take pictures; their equipment is secondary.

me work with an auto-exposure 35 mm SLR, have made the switch because with it they can concentrate on taking pictures rather than twirling dials. All acceptable 35 mm SLRs allow you to override the camera-set exposure in backlight or whenever you want to manipulate contrast. That's all you need for control that the automatic system may not give you. If your camera is the aperture-preferred or the shutter-preferred type, you can use it with the same precision when you have the feel of it.

If you already own a manual-exposure SLR camera, you can use it with great versatility, except that it takes more effort. For those of you who won't switch to automatic exposure because you don't trust it and feel you never will, no debate is necessary, for nothing covered in the *Workbook* is beyond your capability. Manual or automatic, your camera has to be operated with the same visual sensitivity.

Medium- and Large-Format Cameras

Most 2¼″ × 2¼″, 6 × 4.5 cm, and 6 × 7 cm twin-lens and SLR cameras incorporate all or most of the controls found in 35 mm SLRs. In exchange for carrying a heavier camera, you get a larger negative or transparency that maintains better sharp-

2-3. Using a 4″ × 5″ view camera on a tripod, the author was able to compose precisely and develop the negative by an inspection process in the darkroom. Taken along the northern California coast.

ness when enlarged beyond, say, 11″ × 14″. Therefore, where 35 mm equipment is discussed, substitute your medium-format camera and lenses, if that's your preference. There are few experiments, techniques, or exercises in the *Workbook* that cannot be shot with a medium-format camera.

View Cameras

The same cannot be said for view cameras, since taking pictures with one is necessarily slow and deliberate. It is also very satisfying because of the disciplines involved to get superbly sharp images. A view camera has plenty of controls and cannot be handheld, except for a few bulky models that double as press cameras. You will find illustrations made with a view camera in the *Workbook*; I enjoy the precision possibilities of the 4 × 5 format. However, shooting from a tripod without the benefit of a viewfinder at the moment of exposure does limit you to subjects that don't move, or whose movement is predictable. Thus, a view camera is recommended as a second or third approach to photography, unless you are serious enough to try one from the start.

LENSES

Single Focal Length

No doubt many of you have faced the question, "What focal length lenses should I buy?" My response generally is, "What kind of pictures do you intend to shoot?" Following are some thumbnail impressions concerning lenses. You should refer to the *Amphoto Guide to Lenses* and other texts and camera guidebooks for more detailed information.

Wide-angle lenses. The most popular focal length is the 35 mm, followed by the 28 mm which takes in more of a subject from a given distance than does the 35 mm. Wide-angle lenses produce some visual distortion, especially very wide optics like the fisheye or 21 mm. These short-focal-length lenses also provide more apparent depth of field at a given aperture and focusing distance, than a 50 mm or longer lens. Also available are zoom lenses that range from wide-angle to semi-telephoto.

Normal lenses. The 50 mm, 52 mm, and 55 mm are considered normal lenses. An *f*/1.4 or *f*/1.8 50 mm lens can be most helpful in dimly lighted places, as noted in Chapter 7. This focal length is also handy for portraits if you stay several feet from the subject. The 50 mm is a good compromise between wide-angle and semi-telephoto when you're traveling with limited equipment.

2-4. Which lens was used to record the drama of New York skyscrapers? It may have been any focal length from 35 mm to 100 mm, indicating that what you already own may sometimes be substituted for what you hope to buy later.

Telephoto lenses. Actually, focal lengths from 85 mm to 135 mm are semi-telephoto, but the label isn't important. This 85–135 mm range is terrific for portraits, landscapes, and many other subjects. After 135 mm, the telephoto range extends to 200 mm, which you can still handhold, and longer lenses, most of which operate best from a tripod. A telephoto lens reaches out to produce a larger image from a given distance than you get with a 50 mm lens, for instance. Consider zooms that include the 200 mm category before buying a single-focal-length telephoto.

Close-up lenses. For the 35 mm SLR camera, the principal close-up lens is called a macro, and is made most often as a 55 mm optic. This can be used in lieu of a normal lens, with limitations in dim light. A macro lens may focus closely enough to a subject to give you an actual size (1:1) image on film; some models require a special extender to do this.

Zoom Lenses

Zooms have become versatile and plentiful, and they make photography more fun. When first introduced more than two decades ago, zoom lenses were not sharp enough; today, they match any average single-focal-length lens in sharpness. Zooms are also lighter in weight and include close-focusing capability to make them indispensable to enthusiastic photographers who would be well equipped. Choosing a zoom lens requires careful evaluation of zoom ranges, weights, prices, maximum apertures, and close-focusing characteristics.

Short-range zooms. These range from 24 mm, 28 mm, and 35 mm to 70 mm, 80 mm, and 85 mm. Consider one of these as a substitute for a wide-angle, normal, and semi-telephoto you might otherwise buy. You carry more weight and bulk with one zoom than with any single-focal-length optic within the range, but the zoom is handy enough to compensate for its handicaps.

Mid-range zooms. These begin at about 60 mm and extend to approximately 135 mm or 150 mm. The longer the range, the heavier and more costly the lens, but a mid-range zoom can be an excellent first choice when you already have a wide-angle and normal lens.

Long-range zooms. The most popular in this category is the 80–200 mm model, or the 85–205 mm which is similar. Consider a zoom that ranges to about 200 mm as the largest you wish to handhold and carry about. While 200 mm may

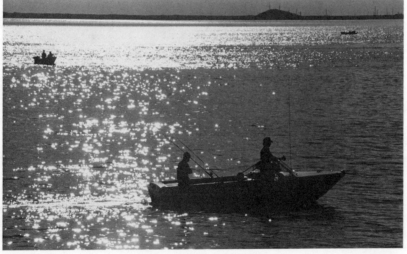

2-5 and 2-6. Zoom lens agility made possible these photographs taken moments apart with an 80–200 mm lens. As the boat cruised by on an Oregon bay, photo 2-5 caught it in the path of sunlight. Photo 2-6 was taken as the direction of the scene turned horizontal; a slight change of focal length brought the boat closer.

seem less impressive than longer telephoto lenses, it can usually satisfy 95 percent of your needs.

Close-focusing zooms. These are a fine substitute for other close-up equipment, whether the lens produces a 1:3 or 1:4 image fully extended. A few zooms focus closely at *any* focal length, and these are preferable to lenses which focus closely only at the shortest focal length in the range. However, either type is a pleasure to have handy.

2-7. Though this may have been made with a 55 mm macro lens, it is an example of zoom-lens close-up capability. Lighting was intentionally uneven to add to the mood.

ACCESSORIES AND OTHER EQUIPMENT

Following are only brief comments and advice, because so many other books and guides are available to keep you up to date.

Lens Add-Ons

Filters. Several are recommended: one or two neutral density (ND) filters ($2\times$ and $4\times$) for exposure controls; a polarizing filter for sky and reflection effects; and a skylight (1A) filter to shoot in shade with some color films. Color-correcting and special-effect filters for use with fluorescent lighting, color blending, and many offbeat effects are all optional.

Close-up equipment. There are sets of two or three add-on lenses and add-on rings to achieve focus very close to a subject. Get advice at a camera shop, since either lenses or rings work fine.

Extenders. A 2× extender mounted between a camera body and a lens doubles the focal length of the lens. It also reduces the effective aperture of the lens by several stops and cuts sharpness. However, it is cheaper to buy an extender than it is to purchase another lens.

Tripods

Eventually, you will need a tripod to help control depth of field, or to expose in low light levels when even nerves of steel are not steady enough. Choose a tripod that extends at least as high as your eye level, and is as lightweight as possible but stable. A compromise tripod weighs about three to four pounds for use with a 35 mm camera. Compact, very light tripods are of limited value. Tripod heads swivel, lift, and tilt, and you may buy one separately from the tripod itself in some brands.

Flash Units

Most camera enthusiasts own an electronic flash unit, but this equipment is not essential to the material in the *Workbook*. Electronic flash is a very expedient way to light a scene when existing light is inadequate. Learn to bounce your flash for pleasanter effects. The subject is covered extensively in the *Amphoto Guide to Lighting* (1979).

Auto-Winders and Motors

A winder or motor enables you to shoot sequence pictures efficiently, and to take portraits without taking your eye from the camera finder to advance film manually. Winders are an affordable luxury while a motor is expensive enough that you had better really need one. Neither type of equipment is necessary to the subjects covered later.

Films

You probably have one or two favorite films already. One fast and one slow film for both color and black-and-white is all you need. Fast films offer the least contrast and the most grain, but

2-9. Again, as in photo 2-4, it is difficult to determine which lens or equipment may have been used, though a shutter speed of about 1/500 sec. is indicated. The camera was an SLR with a 50 mm lens; an auto-winder provided sequences from which the best action was chosen.

the latter is rarely a problem. Medium-speed and slow films have characteristics with which you should be familiar. High-film speed is not required for most of the topics in this book.

Et Cetera

As stated at the beginning of this chapter, preoccupation with equipment is a handicap. The preceding information is simply to launch you properly if you need more equipment in the future.

Few illustrations or exercises in this book call for tricky techniques or out-of-the-ordinary equipment. At least for now, there's no need to be apprehensive that the cameras, lenses, and accessories you own or plan to own will not be adequate.

Take one camera, one lens, and one roll of film on an afternoon's walk or drive. You'll discover that imagination can put limited tools to amazing tasks.

Exercises

1. List the cameras and lenses you now own. Make a separate list of cameras, lenses, and important accessories you would like to own.

Now Own	Want to Own
_____	_____
_____	_____
_____	_____
_____	_____
_____	_____
_____	_____
_____	_____
_____	_____
_____	_____
_____	_____
_____	_____

2. How do you expect the equipment you hope to acquire in the future will help you take pictures? Will it help you see pictures more effectively? Could some equipment you now own do almost the same things for you?

3

Depth of Field at Work

A few years ago, the number one technical problem for the average photographic enthusiast was most often exposure. Today, automation and more versatile cameras have reduced the distracting influence of exposure, but no machine or electric eye has yet been devised to solve depth of field problems. In oversimplified terms, understanding depth of field is the key to controlling sharpness in your pictures. In this chapter, depth of field will be laid bare, dissected, and reassembled as the invaluable principle it can be in competent hands.

DEPTH OF FIELD TECHNICAL DATA

Definitions

Depth of field. This is the distance zone or area between the nearest and farthest objects (or subjects) that will be in acceptably sharp focus at a given *f*-stop and focusing distance, for a specific lens focal length.

3-1. Some types of artistic nature photography require full depth of field, which means complete sharpness from foreground to infinity. This was assured by using a 4″ × 5″ view camera, and observing depth of field through the lens as it was stopped down. The place is the Alabama Hills in California, with the Sierras as a backdrop.

There are plenty of verbal and visual illustrations in this chapter to explain that definition. Here's the first: Focus a 50 mm lens on a 35 mm camera at 7 feet, and set the aperture at f/16. Now read the depth-of-field scale on the lens barrel where you see one f/16 mark appears opposite approximately 5 feet while the opposite f/16 mark is opposite about 11 feet. This indicates that the depth of field, or area of sharp focus, for a 50 mm lens focused at 7 feet totals about 6 feet from front to back. Change the lens focusing distance, and watch depth-of-field indications change as different footage numbers appear opposite matching f-stop numbers.

Depth of focus. This term is *not* interchangeable with depth of field, though it is sometimes mistakenly used as a substitute. Depth of focus refers to the tiny zone in front and back *of the film itself.* The film may vary within the depth-of-focus zone and still record an acceptably sharp image. Nowhere in the book is depth of focus mentioned again because its application is so esoteric.

Focal length. Some lenses are "longer" or "shorter" than others, referring to relative differences between telephoto and wide-angle lenses. Focal length is the distance from a specific point within the lens to the film plane—where the picture is recorded—when the lens is focused at infinity. Focal length is usually described in millimetres. Here's a digest of how focal length affects photography:

— The longer the focal length of a lens, the smaller its field of view. This means the lens takes in less from a given distance as focal length increases.

— As focal length decreases, or becomes shorter, lens field of view widens.

— A "normal" focal length is in the 50–55 mm range because that's approximately the diagonal measurement of a 35 mm frame or picture.

There are wide-angle, normal, semi-telephoto, and telephoto lenses, and each category has its own depth-of-field characteristics which we'll discuss.

Aperture. This is the f-stop or lens opening you know as numbers on a lens barrel. The smaller the number, the larger the lens opening. Yours not to reason why, however; just

memorize the full stops, usually engraved on the lens, and half-stops, usually felt as clicks between engraved numbers.

Focusing distance. When you focus an SLR camera lens, the approximate distance from lens to subject appears opposite an index mark on the lens barrel. This measurement is close enough for our purposes, and you don't need a tape measure.

Depth-of-field scale. On the barrel of most SLR and some other lenses, there's a matching series of *f*-stop numbers on each side of the focusing index mark. As noted before, depth of field is indicated by the distance in feet or metres from one *f*-stop mark to its opposite twin. When you shoot close-ups, depth of field may be measured in inches or millimetres not included on the average lens scale, but often engraved on the barrel of a macro lens. The depth-of-field scale is a fast, convenient reference as you take pictures. If you ever need more precise figures, there are depth-of-field tables printed for various lens focal lengths in technical books or camera guides from manufacturers.

Depth-of-field preview. On many SLR cameras, there's a lever or button that stops the lens down to whatever aperture you or the auto-exposure system have set for a given situation. In this way, you see through the lens a rough approximation of where sharp focus begins and ends in a scene or for a portrait. Because the viewfinder image is small, you cannot see the precise difference between sharp and out-of-focus, but depth-of-field previewing is valuable anyhow. Together with the depth-of-field scale on your camera, previewing is a control you may use frequently.

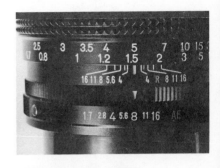

3-3. Typical depth-of-field scale on the lens for a 35 mm camera. This shows focus at 5 feet and depth of field from 4 feet to 7 feet at f/16. What is the depth of field at f/8 where the lens diaphragm is set?

3-4 and 3-5. Focus on the windowpane, set the lens opening at f/2.8, and preview the scene about this way through the lens (photo 3-4). Focus halfway to the buildings, set the lens at f/16, and preview the scene as viewed in photo 3-5.

LENS CHARACTERISTICS

To better understand depth of field, you should be familiar with a few optical laws that give lenses certain dependable traits. Here's a basic principle that influences your choice of lenses for portraits, travel, or whatever: The shorter the focal length of the lens, the more depth of field it produces at a given aperture and focusing distance. For example, wide-angle lenses have greater inherent depth of field than normal or telephoto lenses.

Let's translate this principle into numbers and compare depth of field for three popular lens focal lengths. Each is focused at 10 feet and set at $f/8$:

35 mm lens: depth of field from 5 ft. to 20 ft. (1.5 m to 6 m)

50 mm lens: depth of field from 7½ ft. to 15 ft. (2.3 m to 4.5 m)

135 mm lens: depth of field from 9 ft. to 12 ft. (2.7 m to 3.6 m)

These are approximate figures, but they show clearly what to expect when you choose a lens for specific situations.

Changing Lenses

You can see depth of field increase or decrease as you change lenses through the following exercise. If you don't own lenses in three different categories, perhaps you can work with someone whose equipment augments your own.

1. Set the camera on a tripod, indoors or out, where the light level allows you to shoot at $f/5.6$ or $f/8$ with the film you choose. Beginning with a telephoto lens, such as the 135 mm, frame a specific area you'll be able to duplicate. Focus the lens at 6 or 8 feet, and set the aperture to $f/5.6$ or $f/8$ where the depth of field range will be more apparent than stopped down farther. Shoot several pictures, and either keep a written record or place a small sign in the scene on which you note the lens focal length, f-stop, and focusing distance.

2. Switch to a normal 50 mm lens, and move the camera forward to frame the same area included in the 135 mm shot. Focus at the same distance and use the same f-stop as before. Keep a record or revise the sign in the picture.

3. Finally, with a 35 mm or 28 mm lens, relocate the camera to frame approximately the same scene, focus at the same distance, and use the same f-stop as before. Keep a record or revise the sign in the picture.

Project the slides or make the enlargements to the same magnification and compare. You'll see how depth of field changes for each lens in similar circumstances, and you'll also note that perspective and spacial relationships of objects in your pictures are altered. This can be a fascinating experiment with significance you won't forget.

Lens Suggestions

To *improve* depth of field:

1. Use a small aperture with any lens.

2. Choose a wide-angle lens when it fits the situation, or a normal lens rather than a telephoto.

3. Focus carefully; check depth of field with the preview button and/or with the depth-of-field scale on the lens barrel.

4. Use a tripod in limited light levels where a relatively slow shutter speed makes a smaller *f*-stop possible.

5. Choose a fast film (ASA 200 or faster) for use with smaller apertures. Consider increasing film speed by special push-processing.

To *reduce* depth of field, and to assure out-of-focus picture areas through selective focus:

1. Use a relatively large *f*-stop, such as *f*/2.8 or *f*/3.5, depending on light conditions.

2. Use a longer-than-normal focal length lens, such as 85 mm, 105 mm, or 135 mm, especially for portraits or any subjects you want sharply focused in relation to an out-of-focus background or foreground. The aperture to achieve this will be selected according to film speed, light level, and your depth of field needs.

3. Use a slow-speed film that allows you to shoot with wider lens openings, particularly in bright light.

4. If you must use a fast film, place a neutral density filter over the lens to cut effective film speed and permit larger *f*-stops.

3-6 and 3-7. A 50 mm lens was used for both of these shots; the camera inside the automobile was not moved. Why are the images so different? Because focus was at infinity for photo 3-6, and focus was shifted to the wet windshield for 3-7. Try this experiment on a rainy day.

3-8. Depth of field was shallow because the lens aperture was about f/2.8 with a 50 mm lens. Focus was on the sculpture.

3-9. A Yugoslavian outdoor market in open shade allowed use of medium-speed film, a 1/125 sec. shutter speed, and f/8 with a 100 mm lens. Depth of field was reduced to soften the background.

For more or less depth of field, and when there's time and the shot is important enough, *bracket your focus*. This means, focus at several slightly different points. Later you can choose the print or slide with the depth of field you want.

DEPTH OF FIELD PRACTICE

Trying to take sharp pictures is normal! You focus carefully, and expect some or all of a picture area to be sharp, depending on the focal _____ of the _____, and the focusing _____ from the _____. You also have to hold the camera steadily, or your sharp areas become blurred.*

By now you should be able to see and say approximately how much picture area will be sharp; so from theories, let's graduate to practice in depth of field control. The following three illustrations show a lovely lady sitting on railroad tracks. All were taken with a 200 mm lens on a 35 mm SLR camera mounted on a tripod.

Photo 3-10: The model is out of focus because the lens was focused several feet behind her. A telephoto lens set at f/6.3 has predictable depth of field to make this kind of image possible. Focused as the lens was, depth of field did not carry forward to include the model.

Photo 3-11: Nothing has changed from the previous photo except the point of focus. At f/6.3, the lady is sharp; notice how there's more in focus behind her than in front. It's an optical principle that depth of field increases more rapidly behind a subject than in front of it. Focus slightly in front of a main subject if you want relatively equal sharpness front and back.

Photo 3-12: The lens was focused on the model's hand, and the aperture was set at f/16. Now there's sharpness from the foreground halfway into the background. With a telephoto lens, even at f/16, you have to compromise in depth of field

terms at relatively close distances. However, the human eye operates in the same way, so a sharp foreground and a softer background seem quite natural to most viewers.

More Optical Laws

We know how lenses work, and here is another view of optical laws we can put to work taking pictures:

1. The smaller the lens opening, the greater the depth of field.
2. The closer you focus to a subject, the less depth of field you get at a given aperture.
3. The longer the focal length of a lens, the less depth of field it produces compared to a shorter-focal-length lens at the same aperture and focusing distance.

These three statements will seem less abstract when you've made your own tests, including this one:

1. Find a location with objects that definitely recede with distance, like fence posts, poles, or other objects that are no more than 50 feet away at the farthest point. This depth of field demonstration only works when you can *see* the difference *f*-stops make, and so requires a zone of sharp focus that's fairly near the lens.

2. Set your camera on a tripod and use a normal or semi-telephoto lens. Focus anywhere from 5 to 10 feet from the camera, preferably on a person or object. The model in photo 3-13 was about 7 feet from an 85 mm lens which was wide open at *f*/2. You *must* shoot at least one of these test pictures at full (wide-open) aperture, so choose light and film accordingly, and resort to a neutral density filter when necessary.

3. Shoot the same scene *without changing focus* at three or four other apertures, ending at *f*/16. Photo 3-14 was taken at *f*/4, 3-15 at *f*/8, and 3-16 at *f*/16. Notice how optical law No. 1 has proven true: depth of field increased as *f*-stop decreased.

The exercise represented by photos 3-13 through 3-16 is not difficult to accomplish. What *is* tough is to find a suitable location where changing focus really shows up in slides or prints. A receding fence or wall is ideal; if there's too much space between objects, however, changes in sharpness are often too subtle.

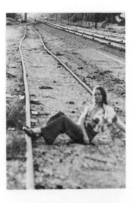

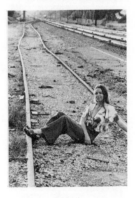

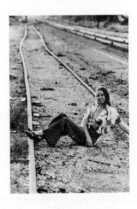

3-10. Where's the focus?

3-11. Has anything but the focus changed?

3-12. How was depth of field increased?

3-13. Test began at f/2.　　　　　　*3-14. Same scene at f/4.*

3-15. More depth of field at f/8.　　　*3-16. Background sharper at f/16.*

Changing Focus

Optical law No. 2, dealing with closeness of focus, can be tested in several ways. For instance, line up several chairs or use a picket fence so your zones of focus are distinguishable. Shoot a series of pictures *at the same* f-*stop*, preferably no smaller than $f/5.6$ so focus will be clearer. Begin by focusing on the closest object, and continue shooting as you focus on objects farther and farther from the camera. Compare prints or slides later to see how depth of field increases as you focus farther from the lens.

Another way to check depth of field in relation to focusing distance involves using a large lens aperture. Make your test in dim light, and use a tripod if you cannot shoot at 1/60 sec. or faster.

1. Focus on an object close to the camera, as I did for photo 3-17 through a shop window. The f-stop for this with Kodak Tri-X Pan film was about $f/3.5$, and you can see how fuzzy the background is when you compare the same area in photo 3-18.

2. For photo 3-18, the exposure was the same as for 3-17, but the focus was on the people in the background. Notice that the record album jackets lined up along the center of the picture are almost all sharp, front to back, in this photo but are mushy in 3-17 where the lens was focused on an object nearer the camera.

In more favorable circumstances, when you can shoot at an aperture such as $f/8$ or smaller, you can split the focus effec-

3-17. Where does the lens seem to be focused?

3-18. What happened when the point of focus changed?

tively. This means you can focus at a point between the nearest object and the background you care about and get both in or near sharp focus.

MORE DEPTH OF FIELD INFLUENCES

By now you realize that the desire for reasonably good or predictable depth of field is integral to all kinds of picture situations. You may also have discovered that along with focus and *f*-stop, another basic setting affects, and is affected by, depth of field, namely, shutter speed.

Shutter Speed Considerations

When you shoot in bright light with a film that permits smaller apertures such as *f*/11, *f*/16, or *f*/22, you will get excellent depth of field all the time, providing you focus properly and not too close to the camera. A glance at the lens depth-of-field scale tells you quickly how close "too close" may be.

However, when the light, indoors or out, is somewhat dim, depth of field limits are affected because you cannot stop down all the way, even with a fast film sometimes, unless you use a tripod. And what if the subject is moving? What good is extensive depth of field when somebody you care about is just a blur at 1/15 sec.? Such shutter speed decisions often have to be made in the shade, when you can use either a fast shutter speed to stop action or a small lens opening for acceptable depth of field, but not both.

You may have come up with a philosophical response already: compromise. Carry a fast film, use flash, pan the camera (see Chapter 6), or whatever, but if none of these antidotes is available, settle for good depth of field and blurred action too.

Photo 3-19 is an example, but before we discuss it, make a guess about the shutter speed used. You will find more on

3-20. One of a series taken in a museum using bracketed shutter speeds. How slow a shutter may have been used here?

3-19. Estimate the shutter speed used.

shooting action in Chapter 7, but so much of photographic technique is connected, that photo 3-19 is a kind of preview. It was taken at 1/500 sec. on ASA 400 film using a 2¼″ × 2¼″ SLR Bronica camera. I wanted the foreground figures blurred and the background trees in soft focus, so I chose a semi-telephoto lens and picked an f-stop by referring to the depth-of-field scale on the side of the camera. My depth of field might not have been adequate at 1/1000 sec., and blur would have been excessive at 1/250 sec.

Make some depth of field and shutter speed experiments for yourself. Choose places where the light level allows a variety of shutter speeds, where you can freeze the subjects sharply or allow them to be blurry. The latter can be functional to denote speed, as in photo 3-19, or decorative to add an artistic touch, as in photo 3-20. The latter was taken at a museum where flash was neither permitted, nor desired. Bracing myself against a railing, I shot a series of pictures at shutter speeds from 1/15 sec. to 1/2 sec. Photo 3-20 was exposed at 1/2 sec. and isn't critically sharp anywhere, but it fulfills the aesthetic purposes I had in mind. Each time you compromise in a choice of f-stop and/or shutter speed, you combine depth of field considerations along with many other photographic options. Such as:

— Can you safely handhold the camera without too much shake?

— Will depth of field explain the background (or foreground) well enough to viewers?

— If a tripod is required, will there be action blur to consider?

— Should you simply use flash and not worry about the natural light of a place?

Each time you answer, you apply good sense for a practical solution.

Minimum Depth of Field

For the times when you want shallow depth of field, the best example is to de-emphasize or neutralize a background, often behind a portrait subject. Using this control is called *selective focus*, which implies that you have some choice over what will be sharp and what may be soft focus. To achieve minimum or reduced depth of field, you can do one or a combination of the following:

— Use a relatively large lens aperture

— Switch to a longer-focal-length lens which provides less depth of field especially when focus is relatively close

— Focus in front of the subject so the background is more out of focus than it would otherwise be

Experiment. Set your camera on a tripod, or some stable place where a group of pictures will have a similar view. Frame a person or object in the finder. Demonstrate each of the above three points for yourself. If your stock of lenses is limited, try a 2× extender with a normal lens, or shoot with a friend whose equipment augments your own. Ask yourself these questions about the exercise and about the resulting slides and/or prints:

— At what lens opening is it dangerous to work because of the need to focus so accurately, or because depth of field is difficult to achieve?

— Is a semi-telephoto lens more flattering to people than a 50 mm lens?

— If there's nothing in front of the main subject, what do you focus on? If you guess, how much adjustment does this technique need?

Zone Focusing

Another depth of field control at your fingertips is called *zone focusing.* Here are the essentials:

1. Decide how far away subjects you want to shoot will be in general. This technique is handy at a party or on the street when you want to shoot quickly "from the hip," as it's sometimes called. For instance, walking along a street, you may decide to concentrate on people about 10 feet away.

2. Choose an appropriate shutter speed, like 1/125 sec. or 1/250 sec., for street shots, and determine the proper *f*-stop to match.

3. Focus the lens using the depth-of-field scale. If 10 feet is the average distance chosen, set the lens at that distance and note the range of feet or metres from one *f*-stop mark to its twin

3-21. In bright sunlight, a shutter speed of 1/500 sec. was chosen to permit an aperture of f/6.3 with a 135 mm lens on an SLR camera. Why? To soften focus on tanks farther from the camera, and to throw the background foliage out of focus.

3-22. On an overcast day in Florence, Italy, during a lavish fete, a lens opening of f/5.6 caught the man sharply, while the animal's motion blurred and the background went soft. A 50 mm lens focused at about 6 feet did the trick.

on the other side. Let's say, the lens will be in focus from 7 feet to 14 feet. Now you can shoot without refocusing when your subject is within that sharp-focus zone you've chosen.

If necessary, refocus using the depth-of-field scale as a guide, to revise the zone to fit circumstances. Using this method, you may compose and snap quickly, with maximum attention to expression, emotion, or action. Zone focusing is especially handy with a wide-angle lens such as the 35 mm or 28 mm because these offer fine depth of field characteristics. There seems to be no doubt that well-known "decisive moment" photographers, like Henri Cartier-Bresson or Garry Winogrand, rely on zone focusing regularly.

Depth of Thought

As you learn to apply depth of field principles, all the confusion disappears. Test your skills with close-up pictures. Shoot some portraits and systematically soften the background by using wider and wider apertures. Or shoot subjects where you can vary depth of field from sharp to mushy foreground, and see what happens in the background due to the distance setting and/or the f-stop you use. Make the most of selective focus to be artistic. Wise application of your knowledge of depth of field can give you a new sense of photographic power!

Exercises

*Here are the missing words for the depth of field practice:

You focus carefully, and expect some or all of a picture area to be sharp, depending on the focal *length* of the *lens*, and the focusing *distance* from the *subject*.

That may have been too easy. Let's see if these four photographs offer more of a challenge.

Photo 3-23: Taken by Susan King who won a Kodak/Scholastic Award. There's no technical data, so we can make educated guesses. Write your guesses here; mine appear below for later comparison.

What lens focal length might have been used for the portrait? What focal length was definitely *not* used?

Photo 3-24: Is it rope, string, or what? Why are parts of the picture far out of focus? What affected the depth of field so drastically?

Photo 3-25: This was taken with an 80–200 mm zoom lens set close to 200 mm. How did depth of field affect the bird at the right? Apply the same deductions to the branch at left and the background cage wire. Would depth of field have been different in color?

Photo 3-26: Though variations are possible, what can you tell about lens focal length, film type, shutter speed, and anything else that influences depth of field? Was this picture of a New York street zone focused?

Author's Responses

Photo 3-23: If a 35 mm camera was used, the lens focal length appears to be longer than normal, perhaps 85 mm or 100 mm. There is no distortion, such as may have resulted from using a wide-angle lens, which was definitely not used. Softness of background shadow indicates soft focus there.

3-23

Photo 3-24: It's shag carpeting photographed with close-up lens attachments over a 50 mm lens on a 35 mm SLR camera. Depth of field is very shallow as you focus closely to a subject; the lens was about two inches from the carpeting, which was lighted by one floodlight and one cardboard reflector opposite it. The camera was handheld, so the aperture was about f/11, accounting for soft focus areas resulting from such close focus.

3-24

Photo 3-25: Because medium-speed Plus-X (ASA 125) was used, the picture had to be taken at f/8 with a handheld SLR camera. The lens was focused on the bird at left, which is sharp, but the foreground branch and the bird at right were slightly out of focus. The cage wire is also in soft focus. Use of

3-25

3-26

a color film with equivalent ASA speed would have produced exactly the same depth of field, had other circumstances remained the same. A faster film could have resulted in greater depth of field.

Photo 3-26: The lens focal length was between 35 mm and 50 mm; a longer focal length would have compacted the background noticeably, while a shorter focal length would have made the people somewhat larger in relation to the background.

The film type happened to be Plus-X, but could have been any medium-to-fast film. A slow film, like ASA 25, might not have produced as much depth of field because exposure would have been less than f/8 or f/11 and 1/250 sec., which stopped the action nicely. The focus is sharp from front to distant background; any lack of sharpness is due to subject movement.

The picture was zone focused, though the nearest people were probably 15 feet away and focusing on them could have produced the same depth of field effect.

Composition: The Way We See

Years ago I planned to collaborate with a painter friend on a book about photographic composition. From the references we collected, I kept two books, one of which began: "Composition is to a picture what 'IT' was to the old-time movie star. . . ." This was followed by a dictionary definition of composition as, "The art or practice of combining the parts of a work of art to produce a harmonious whole." The author added that *harmony* (italics mine) should be the objective of photographers who "want to feel proud of their pictures."

What is harmony to you? Does it imply that elements of a pictorial composition work together? Good, we agree, but how can we orient ourselves to the strange relationships of objects or people or both that we see in some current photographs? For the moment, let's say we each have the freedom to follow a strong personal approach to composition, whether it be called "wild" or "bizarre" by some viewers.

The second reference book said wisely, "You will learn how photographic composition is determined through a combination of technique and artistry," which the writer then said was based on "rules" the reader would discover could be broken.

My friend and I lost interest in our book project, maybe because trying to discuss image-making via conventional "rules" made us uncomfortable. Rules are inhibiting to creativity because they connote a rigid concept of composition, and rigidity is painful to art and self-expression.

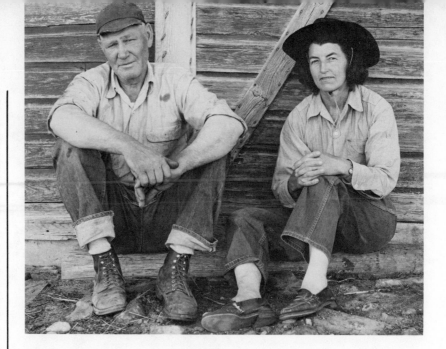

4-1. *Analyze the composition of this double portrait. How did your eye flow?*

GUIDELINES TO COMPOSITION

Composition is *the way we see*, translated from camera viewfinder to prints and slides. Composition is the visual arrangement of subject matter—its design—in the finder, on film or paper, and prior to that, composition is the framework of visualizing in the mind's eye.

Conventional composition, which has a certain balance and order in the arrangement of subjects, is still alive and fundamental, but is today modified by and supplemented with various offbeat ways of seeing exemplified by photographic styles seen in magazines, books, and exhibits. I'm not recommending all avant-garde photographers as role models, but they are forerunners in a generation of artists who emphasize the atypical. Some of their pictures are downright irritating because they glorify the trivial or distort image design in ways that seem contrived. However, nonconformists make us look at the world, through their pictures, in new ways that can be beneficial and enlightening if we're open-minded.

Since rules tend to be smothering, we'll deal in guidelines. Most good artists and craftsmen learn the right way to do something before veering off in a personal direction. Their style then evolves from breaking the rules, or from following them with unique intensity and interpretation.

Content: *What* We See

Let's make a distinction that may already seem obvious. The way we see is the structure or design that finally arrives on film and paper. *What* we see, the *content* of a picture, often influences composition, through shape, size, direction, pattern, and other qualities that help dictate how an image is composed. Sometimes you may be irritated that a ridiculous

subject appears to be spotlighted by publication or exhibition, but always try to separate content from composition. Be aware of *how* something is photographed, of the relationship of people and things, even if they're offbeat, for this can lead to your making variations in your own work that lift it above the humdrum. At the same time you learn to recognize effective ways of seeing, you're going to be both conventional and more daring when circumstances permit.

ELEMENTS OF COMPOSITION

These are the basic elements or ingredients of composition, all of which fit into place, perhaps a few at a time, as you shoot pictures.

Design

Design is a synonym for composition. In a photograph, it is a two-dimensional plan made up of lines, forms, and spaces between them. Converging lines often represent perspective, as objects recede from the lens, but, because photographers also compose and photograph flat patterns, not every scene or subject includes an illusion of depth.

As you design a scene or portrait in the camera viewfinder, you're following a sense of personal order, editing and selecting according to practical and aesthetic motivations. These are both learned and instinctive. A course in basic design, from an instructor who can blend handling the elements mentioned below with an appreciation for your individual feelings, would be very valuable to you. If not a course, dig into some books for more about basic design.

4-2. An unconventional composition, but why? Should it be cropped to a vertical?

4-3. Separate the content from the composition, and decide if you like the organization of this Polaroid Type 52 image by Mindy Arbo. Her study of a small-town bank has mood evolving from the light and the dominant shadow.

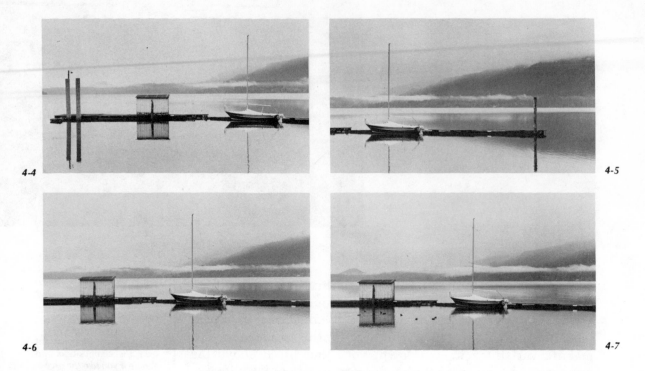

4-4 4-5

4-6 4-7

4-4 through 4-7. The changing composition of these similar photographs is discussed in detail in the text. Explore the alternatives of any picture situation where there's time and the subject is worth it.

Dominant and Subordinate

Within most pictorial designs, there's usually a dominant form, or several forms that share dominance. Generally, it is the size, position, shape, angle, or storytelling importance of an element that makes it stand out, but sometimes a striking color is seen before its literal form. In a portrait, we often look first at the eyes, which makes them dominant. To draw attention quickly in a composition, place the main subject in or near the center of the picture, or place it at a steep angle in respect to the edges and whatever else is around the angled subject.

Related to the dominant subject, and supporting it visually, are *subordinate,* or subdominant forms and lines that are located and sized for secondary visual competition. Photos 4-4 through 4-8 all show the dominant/subordinate principle at work. Often unconsciously we choose a figure or object to dominate a composition in order to clarify the meaning of the picture, or to achieve greater impact on viewers.

Eye Flow

When you look at a picture, notice how your eyes tend to enter at one edge, or at some point within the format. Your vision then flows along one or more paths until it switches direction, perhaps several times, and it then may run off another edge. This phenomenon is called eye flow. While you don't usually

4-8. The two circular sieves are dominant forms because your eye glances at them first, followed probably by the can with the bright container on top of it. Visually supportive are the subdominant smaller forms and bottles at far right, plus the third sieve. The background is out of focus purposely for better display of the sharper shapes. Place tracing paper over some of your pictures and lightly diagram and label the elements of composition.

deal with it consciously in the camera viewfinder, it's fascinating to analyze your flow of vision into and around prints and slides. If you find it difficult to decide how your eyes travel over a design, then think about the visible and invisible lines that tie the composition together and make it work.

Balance

This element separates the traditionalists from the modernists. The former like landscape pictures that are not equally bisected by the horizon, while the latter may advocate images that are half sky and half land, or perhaps very unequal proportions. Traditionalists prefer people and things slightly off-center in prints and slides, while modernists forcefully put somebody far to the side or in dead center—where they get more attention. However, fundamental design theory still holds that a dead-center, equally divided composition is *static*, because such even balance hampers eye flow and undermines variety.

The opposite of static is *dynamic* composition, created by strong moving lines and forms, and by contrasts of size, color, or location within the picture format. Curving or angular forms and lines that oppose each other, dramatically receding perspective, or fisheye views may help produce dynamic visual designs. Subjects in action may also contribute to the dynamic design of an image, depending on your choice of lens, camera angle, and background.

59

4-9 and 4-10. How do these different views taken from the same spot compare in balance? By direction of lines and by tones they are intended to have impact as well as effective design.

Contrasts

While you're photographing, also be conscious of other types of contrasts, of large vs. small, dark vs. light, close vs. distant, active vs. passive, smooth vs. rough, and colorful vs. pastel. These opposites occur in all sorts of subjects, and when you have some control over them, they can help make a successful composition.

As an aside, maybe you've heard of "dynamic symmetry," a theory of pictorialism based on the placement of forms and lines according to almost rigidly prescribed patterns, such as an S-curve. This is an outmoded aesthetic which tends to be inhibiting because it is so formulized.

Color

Color isn't usually an element of composition in its own right, but forms or lines may arrest the eye (dominate) or support a design (subordinate) because of their hue, intensity, and chromatic relationship. Spots or areas of color may be responsible for visual *plasticity*, which means the eye flows from foreground colors in lines or shapes to similar hues in background forms and lines. The painter Cézanne was a master of planned plasticity, which is a subtle phenomenon.

Did you realize that there is color in black-and-white pictures? Deep blacks, strong detailed whites, and pearly grays substitute nicely for hues of the rainbow, and basic pictorial design in black-and-white is similar to that in color, because the same principles apply.

A PROJECT FOR SEEING

Fortunately, this country does not have a government bureau of design and aesthetics that must approve photographic compositions before they can be shown publicly. That means your pictorial opinions and practices are valid when they're also effective in presenting your ideas and impressions, and you can at least explain them to yourself.

Keep in mind that guidelines are supposed to be flexible to encourage individual personal style and effort. My tastes change, and so will yours. I can defend a visual style that is provocative or rebellious if it moves me, even to outrage. Only deceptive contrivance irritates me consistently.

I recommend the same open-mindedness to you. It requires a mixture of tolerance, understanding, artistic and technical discipline on your part, as well as continued exposure to images in all styles, whether done with a camera or other media. The more you can assimilate of other people's compositions, the more effective yours may become.

Here's a *Workbook* project: Take a walk, or a trip, or explore wherever you wish with your camera. Consciously compose your pictures with care. When you shoot quickly, try to be aware of how you arrange or design images in terms of dominance, balance, and the like. Shoot some solid, purist compositions in the manner of Ansel Adams or whomever you admire. Such masters do not make static pictures, nor are their photographs unbalanced or offbeat. As an aid to this part of the project, you can use a tripod if you wish.

Before, during, or after shooting the above, experiment with alternate compositions that you consider to be offbeat, bizarre, avant-garde, or sophisticated in the visual risks you take. You'll have to interpret these terms for yourself, but do something "different" from your usual seeing. Perhaps you

4-11. The color in black-and-white results from a strong tonal scale here, though in photos 4-4 through 4-7, color is inferred by subtle tones. A hotel in Los Angeles has been converted to an almost abstract pattern.

4-12. An example of confused composition where your vision darts around without planned direction from subject matter because the latter is jumbled. The man in the foreground and several other shapes compete for dominance. Too many subordinate forms are of equal visual importance but are not very interesting. A different camera angle and a more limited vista may have improved the composition.

should look first for inspiration from pictures in photographic magazines, books, or exhibitions. You'll probably see some images that I equate with the chilling sound of fingernails on a chalkboard! Don't attempt to copy, but try instead for compositions and subjects that are new to you, whether conventional or not. Sometimes you can *feel* the influence of other people's work flowing through you.

It may be worth shooting the same subjects in several ways—straight and offbeat, for example. Whether these words mean the same to you as they do to me is less important than that they stimulate you to experiment and to take visual chances. You have nothing to lose but your inhibitions. You'll grow in confidence as your pictures reflect your changing tastes.

CONTENT IN COMPOSITION

Strong, memorable pictures are often dependent on their subject matter rather than on how people, places, and things are composed. Prime examples are images of celebrities, news shots of emotional crisis, and esoteric travel scenes, all of which may seem fascinating even if the photographer's artistic skills are limited. Catch a zoo animal in a silly pose, and your picture can be exciting despite a confusing background or ordinary camera angle. An unusual subject or just a "clear" picture may mislead you into thinking your composition is effective, when all you've done is to exhibit a good sense of timing as something interesting happened. What I mean by "effective" is discussed shortly.

Real Vs. Abstract

Here's another phase of content within composition. Photography is generally a literal medium from which you expect a

sense of reality and subject recognition. From within reality, through imaginative manipulation of cameras, lenses, and materials, you can also extract what might be called abstract images. These segments of reality then gain an identity of their own.

This distinction also separates content from how it is handled (technique) and how it is composed or designed. The abstract or surreal in photography is often appealing because of your individual seeing.

Other Influences

What you shoot may direct *how* you put it on film. For instance, a skyscraper is vertical, and may best be pictured in that format; or you may tend to picture children playing *across* the scene with a horizontally held camera. A mountain range can also dictate a horizontal composition, but the foreground and the sky can influence direction as well.

Some compositions are created in response to mood, emotional reaction, or artistic inclination. Lighting, too, influences what and how you photograph. A pastoral subject with rows of trees or a field of grain will appear quite differently according to the time of day.

Pull out a few of your successful slides or prints and analyze how the compositions came to be. All the controls are available; you'll be discovering the subtleties too.

CHARACTERISTICS OF COMPOSITION

You probably know why composition is such a formidable subject to write about or discuss. Though the elements that help make a worthy image design are familiar, evaluation of them during and after picture-taking is subjective. Consequently, we're apt to get into a verbal maze where words such

4-13. Like photo 4-11, the subject was seen for its pattern, and its sense of reality is secondary. Simplifying a subject is often a key to seeing it more abstractly.

63

as "good" become weak and relative. I've used the term *effective*. Here are certain characteristics that effective, successful compositions have in common:

Visual Impact

An image that works, that tells its story well, has visual impact. It may be exciting because of the subject, but it must also have a design, dynamic or delicate, that arrests the eye. A sports scene may be dynamic, though a quiet, peaceful landscape or a passive interpretation of people may also have a magic that provides forceful appeal.

As mentioned before, the drama of a subject isn't always responsible for an effective composition. For instance, a beautiful nude woman photographed walking nonchalantly down a busy street can certainly be a striking picture, but it will be less so if composed nervously with haphazard background and distracting surroundings. To be more than a freaky snapshot, such a composition has to be relatively direct and simple; incongruities need organization to work. A low camera angle, a long lens that blurs the background, curious contrasts to help the viewer understand what's happening, and strong sidelighting are all approaches to lift such an image from the odd-ball classification.

Personal Seeing

Effective composition usually indicates that the intent of the photographer is realized. The purpose of a picture—to tell a story, be a portrait, or explain something—is accomplished through its composition, to reach as many viewers as possible. Here are some of the words you might apply to personal seeing:

satisfying	symbolic
interesting	informative
mysterious	provocative

Add to the list for your own pleasure. Define *effective* for yourself, and you will be closer to understanding your own intent.

Personal or subjective photography today is sometimes contrived, though this is hard to prove because people are loath to cop out on themselves! You have seen, or will see, commonplace subjects presented in stark compositions, bizarre happenings where visual organization is ignored, off-

4-14. It is tempting to some photographers to try and explain disorganization by claiming it has "inner meaning," or some such mystic connotation. In truth, this reflection shot on a New York street has a certain mystery due mainly to its confusion.

beat portraits, nudes, or human relationships that are supposed to shock or titillate you, so you ignore the lack of careful composition. Along with the shallow and contrived are such words and phrases as "inner urges," "personal concerns," or "resonances." These may be a cover for the inexplicable, or a vague reference to things seen or felt in the past. Try to separate pretentious-sounding statements about pictures from the impressions *you* get about image treatment. I use the term *articulate deception* for an arty contrivance that's presented to you as an artistic composition.

Study offbeat images to help expand your own creativity. Just as you *avoid* trying to conform to outdated, or too conventional, theories of design, you may *set out* to experiment in directions that you may have considered objectionable. You cannot tell if someone else's photograph is without guile, but you can use it to stretch your imagination. The sophisticated composition (another subjective description) in the modern mode (as you see it) may have lasting aesthetic value for you and expand your regular ways of seeing.

BEFORE AND AFTER CROPPING

Composition begins in the imagination via a process called *pre-visualizing,* which means to form a mind's-eye impression of how you want to organize a subject before shooting a photograph of it. Seeing effectively with a camera becomes more instinctive with experience. In time you can lift the camera, view quickly, shift if necessary, and shoot whatever you visualized, now seen through the viewfinder. Pre-visualizing is especially valuable for fast-changing sports or street scenes that cannot be planned, but it is just as helpful for situations where you compose deliberately with lots of time. (Planned carelessness made to look casual and authentic is often a vehicle for articulate deception as well.)

The Visualizing Process

Make this test with your camera on a tripod. Choose a place that has worthwhile picture possibilities, such as the zoo, a park, or a schoolyard at recess. Shoot an entire 36-exposure roll of color or black-and-white from positions relatively close to each other. Use as many lenses as you wish, and vary your compositions of people, places, and things. Shift the camera by logic, instinct, or whim, but limit your wanderings and your time to make the test results more homogenous.

Try to visualize each frame before shooting the strongest composition possible, eliminating everything that doesn't work. Decide what's important, and accentuate it by camera angle, choice of lens, lighting, timing, or maybe by tonal contrast. Shoot variations of whatever appeals to you. A zoom lens is a fine tool for this exercise. Be conscious of your reason for making each exposure. Your film should be limited, but leave no picture opportunity unexploited.

Later, edit the pictures carefully. Toss out the ones that don't please you, but keep any worth reconsideration. Don't expect to get many spectacular slides or prints, but you may be surprised.

You can judge your success in visualizing by comparing what you *planned* to get on film with the images that *actually got there.* Using a tripod is a discipline that makes you ponder each picture more carefully.

Test yourself like this at intervals; it will help you form sharper, more valid mental pictures before and during camera exposures.

Cropping Later

The emphasis so far has been on effective composition while taking pictures, but some of you may be thinking, "I can crop the shot later." There's nothing wrong with second-guessing yourself to improve what you've captured on film. By thoughtfully enlarging a negative or slide, or by tape-masking a slide for projection, you can eliminate distracting material along the edges. Efficient cropping is an ally to in-camera composition that can be improved, *but it shouldn't be a substitute for seeing tightly and precisely through the viewfinder.*

Some people insist on printing the entire 35 mm negative, or projecting the whole slide, with no cropping. Try it as a training aid if you wish; consciously compose the full 35 mm format, but crop later if it improves the image. It is also

satisfying to attempt no-crop compositions with medium and larger formats, but if your camera makes square pictures, you may *plan* the cropping in the viewfinder as you shoot. Working for full-frame images is fine discipline, whether you change your mind later or not.

Photos 4-15 and 4-16 illustrate cropping that paid off. Parts of 4-15 have already been cropped from the original 35 mm negative, to eliminate unnecessary confusion. On closer study, I decided that the most graphic section of the picture was at the bottom, so again I cropped it to create 4-16. Now the big eyes are dominant along with the sign that makes a visual pun.

PRACTICING COMPOSITION

Just as I cannot comment on your pictures, I also cannot require you to get out there and practice photographic principles or techniques. What the *Workbook can* do is analyze and compare images like those you may shoot in selected case histories that follow. Transpose my picture situations to your own experience. Be encouraged when you realize how many different twists and turns are possible on the path to developing competent personal taste. From plenty of experience comes freedom in photography.

What's Conventional?

Styles in aesthetics change, but "conventional" usually connotes a kind of formal balance in a composition, exemplified by the portrait of a Wyoming rancher and his wife in photo 4-1. Did you look first at their eyes and faces? Most viewers do. Next you may have observed how they're sitting and the directional lines of their bodies in relation to the boards behind them. The composition is cohesive because the people are

4-15 and 4-16. Cropping was employed to extract the most graphic parts of this window reflection. Do you prefer the nearly whole photo 4-15 or the cropped version?

4-1

seen in visual harmony with their setting. Your eye flows from the man's face, down his arms and over to the woman's hands, then to her face, and back to the man's face via the diagonal board. Everyone doesn't have to view a composition in the same manner, however; a successful image design reaches a majority of viewers, whether or not they would agree fully on the visual analysis.

The composition is unconventional in photo 4-2, with the child centered in a style that traditionalists eschew. The picture happened quickly as I strolled through a park, looking at the world through a 65–135 mm zoom lens on an SLR camera. It isn't often that a dominant figure or object appeals to me when it is dead-center, but here the design feels right, since it emphasizes the child's gesture and isolation.

This question arises: Why not crop photo 4-2 to a vertical format with perhaps more background on one side of the child than the other? My aesthetic sense responds that if revised to a vertical, the image would be more ordinary and lose much of its impact. Crop it for yourself and see. Each of us needs to stand up for our personal convictions which grow along with self-confidence in photography.

4-2

Exploring for Alternatives

As pointed out earlier, nonprofessionals should rejoice in having the leisure to explore a subject at length without pressure to please anyone in particular. When you make opportunities to spend time with a subject or situation, you always find alternatives in composition that may otherwise be overlooked. That is what happened at Lake Quinault, Washington, on an overcast morning with no wind to disturb the water (photos 4-4 through 4-7). Here are four of the ten frames I shot of the dock-and-boat arrangement with my 65–135 mm zoom lens on a 35 mm SLR. The film was Plus-X which enhances contrast with relatively fine grain.

Photo 4-4: There's a kind of competition in the composition. Your eye may not be certain where to look first because the pilings, the shed, and the sailboat have similar importance in the design. Maybe you glance at the sailboat first because of its shape and connotations, but your eye is also drawn to the shed, which is nearly centered.

Photo 4-5: Now you see the sailboat first, followed by the gray hill and the black dock line. Competition for dominance

is alleviated; the vertical mast and piling are counterpoint to the picture's horizontality.

Photos 4-6 and 4-7: Compositional emphasis changes again, and the sailboat is dominant, supported by the shed and gray hill. The fleet of passing ducks adds interest to 4-7, but you may prefer the simplicity of 4-6. Which of the four variations is your favorite? I'll tell you mine in the Exercise section of this chapter.

The lake scene in color was cool blue-gray, with almost exactly the same elements of design that you see in black-and-white. While color often influences composition, many subjects may be framed similarly in the viewfinder in either medium. Next time you can arrange it, shoot the subject in black-and-white in one camera and the same subject in color in a second camera, even if you have to borrow one. Consider whether you "think in color," and if so, whether it makes much difference in the way you compose photographically.

A Sense of Balance

The concepts of static and dynamic balance in composition were discussed earlier. How do photos 4-9 and 4-10 compare in regard to those values? Is one more dynamic than the other? To me, they are relatively equal. In 4-10, the diagonal traffic light standard is dominant, but it is framed by structures at left and right, and lies across a vertical background. In 4-9, there is a dark base on which the composition may stand. Vertical lines and forms with an interplay of shadows are balanced by useful horizontal lines. Tonal contrast plays a dynamic role in each version of this Manhattan street scene.

When I see visual geometry such as appears in photos 4-9 and 4-10, I'm reminded of the Dutch painter Piet Mondrian (1872-1944) whose strong, abstract compositions have, I feel, influenced more photography than many people realize. No formulas are involved, but a suggestion of structure underlies Mondrian-inspired pictures. Check the library or bookstores for more about Mondrian so you'll know better how his seeing directs ours.

The Influence of Focal Length

In Chapter 3, under "Lens Characteristics," you were instructed to shoot a series of pictures of essentially the same scene using various lens focal lengths. With this experiment you demonstrated how perspective and the relationship of ob-

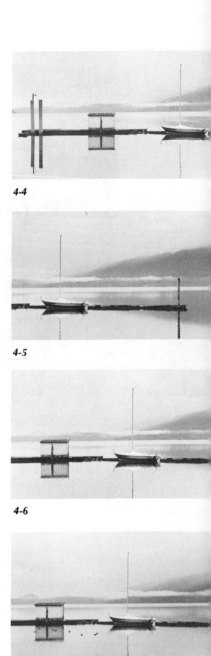

4-4

4-5

4-6

4-7

4-9

4-10

jects change with focal length, and you may also have seen how the design of pictures was altered. Different lenses "draw" the same subject matter in characteristic ways you can count on when pre-visualizing.

My examples of this begin with photo 4-17, taken with a 35 mm lens on a 35 mm SLR camera (used for all three shots, of course). The car looks elongated, the model seems rather tall in relation to the car, and there's a mild feeling of distortion.

Photo 4-18 was shot with a 50 mm lens, and the relationship of car and model appears more normal. Photo 4-19 was taken with a 135 mm lens. Here the car is more compact, and the model seems relatively shorter than she did in 4-17. Focal length does influence composition, even when you attempt to avoid change. Wherever you take pictures, a demonstration like this will be remembered.

Order Out of Confusion

Driftwood is always a confusing subject when it is massed on a beach; it takes dedicated effort to visually untangle it in search of worthy compositions. But nature's mess inspires some artists and photographers to seek order, and I welcomed the challenge to find a unified image, photo 4-20, within the maze of twisted, textured limbs. Many times I planted my tripod legs in the sand, or on driftwood logs, and sighted through my 4″ × 5″ ground glass, only to be dismayed by the jumble.

The effort finally paid off with this section of a dominant tree flowing from bottom left to top right. Other forms echo this movement for which there is visual opposition supplied by dark trunks in the background. If no driftwood is handy, test your viewfinder editing skills in an automotive junkyard or in a flower garden where you must sort through confusion to create aesthetic order.

Look Both Ways

It is unusual to find both a horizontal and a vertical composition of the same subject from a single viewpoint, but it is good practice to look for them. One Sunday when the fleet was docked at a small fishing port in the State of Washington, I came upon the young man mending nets, photo 4-21. I was using an 80–200 mm zoom lens on my 35 mm SLR, and shot the horizontal format first, then switched to the vertical (photo

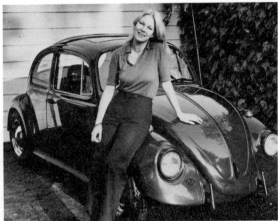

4-17. 35 mm lens.

4-18. 50 mm lens.

4-19. 135 mm lens.

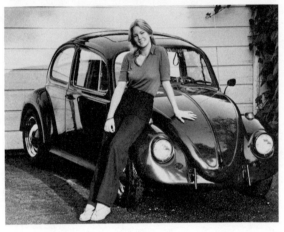

4-20. Driftwood on an
Oregon beach offered a
photographic challenge.

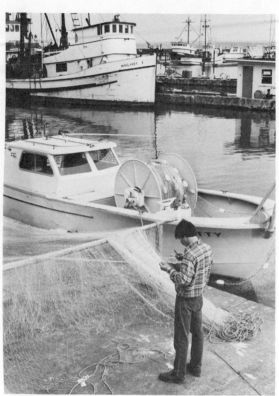

4-21 and 4-22. Each format has its own characteristics.

4-22), which says more about the man's surroundings and allows your eye to wander into the distance. The horizontal picture is more informative about net mending and focuses attention on the man and his immediate setting. Which version tells a story more effectively?

Each photograph has its own merits: 4-21 may be more artistic, while 4-22 gives more information. I have printed them both to underline my suggestion that you should grasp *all* the photo possibilities while you can, and do your editing and eliminating later. You'll stretch the limits of composition this way, and test your seeing constantly. Have a dialogue with yourself when faced with choices; no matter what visual points you discuss mentally, you'll be glad you did.

Exercises

1. Look again at photos 4-4 through 4-7. Did you choose a favorite? Mine is 4-5 because of its simplicity. There's more gray hill and fewer foreground elements. Of all four shots, I feel I'd enjoy seeing it most often.

Choose one of your own prints in color or black-and-white, and fasten it on the page where shown. The reason for this, is to have you consider its pictorial composition. A picture you like is preferable, so you're not unnecessarily critical.

Place photograph here.
Slide may be held for viewing.

Ask yourself these questions about the composition of your photograph: What is the *dominant* form or shape? _____ Is that where your eye goes first? _____ Rather than a dominant form, is there a pattern of smaller shapes or lines that seems dominant? _____

What forms in the picture are subordinate? How do they support the dominant forms visually?

How could you have taken the picture to improve the composition? (If changes seem minor, say so.)

If you've exhausted analysis on one picture, switch to a few others that you like. The point is not to denigrate the images, but to determine how effective your seeing was. Now go on with the following questions about several photographs. Give them numbers if you want to separate your responses.

How could the picture(s) be improved by cropping?
Where and how much?

With a grease pencil, or a Stabilo pencil that writes on anything, and using a straightedge, lightly crop your print(s) to improve it as you described. Slides may be cropped using opaque tape.

Photos 4-23 and 4-24 were taken within moments of each other with a zoom lens from the same viewpoint. Several of the people in photo 4-23 walked out of the picture, and photo 4-24 was taken with the lens set at a slightly wider angle to include the horizon. Birds, tire tracks, and shallow stream across the foreground remain the same. I like both compositions, but prefer one over the other. Before reading my brief comparison, jot down your own.

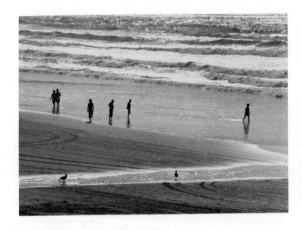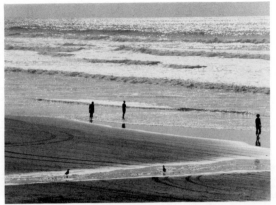

How are the pictures different in mood?

How does the composition influence what you wrote about mood?

Can either picture be improved by cropping? Hold opaque paper or cardboard along one or more edges, and experiment.

Author's response: Photo 4-23 has the preferable composition because it is more intimate. Without the horizon, we seem closer to the people, and there are more of them to interest us. Photo 4-24 seems somewhat empty by comparison, yet it should have been taken, in order to exploit the visual possibilities of the scene. The comparison also illustrates that differences in composition need not be dynamic to be distinct.

5

Color: Do You Take It for Granted?

Perhaps you can recall when color photography was considered a lot more difficult than shooting in black-and-white. You could often manipulate a bad black-and-white exposure in the darkroom to make an acceptable print, but color printing was still esoteric and expensive for hobbyists. Back then, color meant slides to most people, and exposure was considered a weighty matter.

Eventually, color negative films and expedient papers and chemistry resulted in a preference for color prints. Today, machines print pictures so efficiently that a majority of images taken by nonprofessionals are enjoyed as prints. Slide shooters are in the minority, though the pros use transparency films because publications prefer them.

Technical progress has made color photography no more complex than black-and-white. Overexposed color negatives can be printed so well that you don't notice any errors. Underexposed color negatives allow for minor corrections, but you're likely to get muddy-looking prints with little shadow detail. Even so, automatic cameras and flash units, automatic processing, and reliable materials all band together to allow us to push the shutter release and let "them" do the rest. Almost.

COLOR EXPOSURE PRIMER

The following data is abbreviated in staccato fashion because it is readily available elsewhere:

— Avoid *under*exposing color negatives; bracket more toward overexposure if you want variations.

— Avoid *over*exposing color slide films because washed-out transparencies are disappointing. Bracket toward underexposure if necessary. You'll get better color saturation.

— The exception is shooting color negative film such as Eastman 5247 or Kodacolor, when *slides* are preferred over prints as the final product. One-quarter to one-half stop less than normal exposure results in richer color in most slides. I have been rating Eastman 5247 color negative stock at ASA 125 (instead of ASA 100) for years, and I'm pleased with the slides produced in general.

— You learn from experience which subjects and lighting conditions lend themselves best to exposure manipulations with your choice of color films.

•

DON'T TAKE IT EASY

Photography problems discussed throughout the *Workbook* all involve color films and color considerations, even if examples are shown in black-and-white. Your film, the type and intensity of the light indoors or out, and what you're shooting all influence decisions about depth of field, action, and other topics. So if we think hard about technique, depend on good equipment, and are conscientious, how is it that we tend to take color for granted?

The fact is, we don't *think in color* often enough. We accept the color we see unconsciously, and presume the print or slide will show the colors we shot with relative fidelity. Color photography is so uncomplicated that we tend to make nice records of people and scenes, and ignore the emotional and/or psychological values of color.

Lorraine Thompson won the 1979 KINSA color first prize for what she called a "happy accident." Excellent timing and a lovely arrangement of textures and colors produced an artful image. It's another example to inspire your resourcefulness around home.

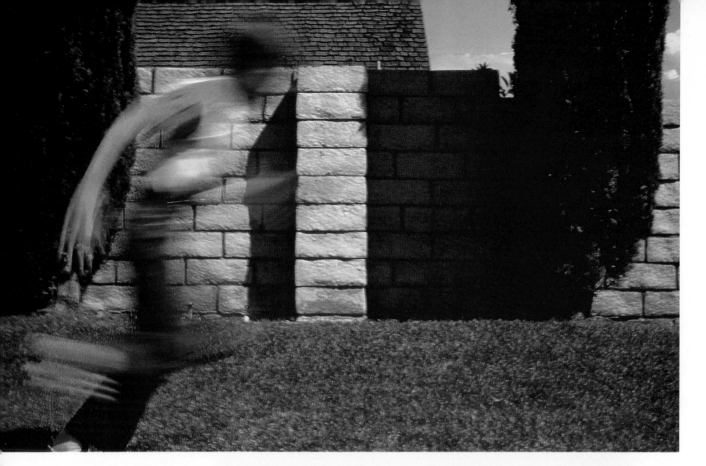

Ronald D. Schurter imaginatively used blur, color, and shape to create this mysterious image. Notice how the curved dark portion at the right relates to the curved blurred figure at the left.

Dan Steinhardt captured the brilliant color of this tree with his 35 mm SLR. Subjects don't have to be moving to be vibrant.

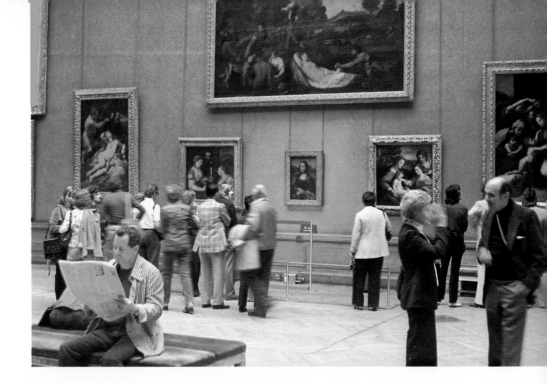

The Mona Lisa, at the Louvre in Paris, is skylighted brightly enough for a 1/30 sec. hand-held exposure. This photograph was made with a 35 mm lens on an SLR camera. People and paintings add to the ambience. Note the occasional blurred hand or foot.

Twilight in Chicago called for a 1/4 sec. exposure hand-held. Such a slow exposure is always risky without a tripod, but here it was successful because of the subject.

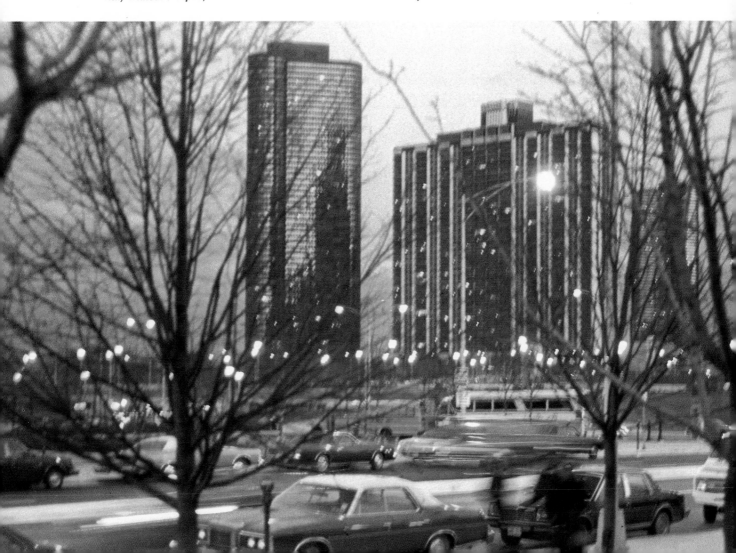

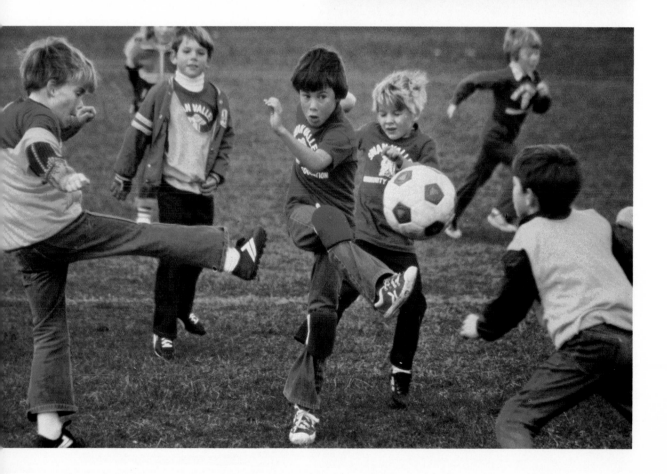

Harvey Hill placed flowers in sunlight near a window with a dark background, and photographed them with a 50 mm lens and a closeup attachment. Composition and color were careful choices.

This 1979 KINSA prize-winner by Charles H. Rogers illustrates action photography at its best. Make a series of exposures in such a situation—don't try to make just one or two lucky exposures.

THINKING IN COLOR

In other books (some listed in the "Suggested Reading" section at the end of the *Workbook*) and in current magazines, you'll find facts and essays and pictures that discuss and illustrate what color means to different people. How do *you* interpret color? What are your connotations for blue? Red? Orange? Green? What does a pastel yellow do for you? What colors excite or disturb you? What's an advancing color (a warm one)? Or a retreating color (a cool one)? Do some colors connote sadness or happiness to you? These are some aspects of thinking in color.

"Wait a minute," you may be saying. "We don't often have the chance to arrange, manipulate, or escape certain colors and combinations we see. Just because we photograph what's there doesn't necessarily mean we're taking color for granted."

That's a reasonable disclaimer, and among my color photographs are a number taken when I had no control over the color itself. But more importantly, we should realize how we're drawn to take pictures *because* of a response to color and combinations.

One can become rhapsodic about color. One can also rationalize about being moved to take what turns out to be a meaningless picture because the color was such a turn-on. Color gets to you, so you have to be aware of what it contributes to what you're seeing. When you cannot change the color (except by filters for special effects), you may still be able to exploit it.

Whenever possible, place contrasting colors next to each other for dramatic effect. When an overcast sky creates pastel colors, expose with and without a warm-up filter, or tint the whole picture gently as you wish. If a brilliant sunset inflames your imagination, try to silhouette someone or something in the foreground, so the scene isn't just a backdrop for emptiness.

Consciousness of color includes how it is likely to affect the viewer. See and think color, and you'll never take it for granted. You may seem rather casual about shooting color, which is the mark of a well-trained amateur or professional. At that point, the visual and emotional effects of color have greater meaning.

Exercises

Let's try to find out to what extent you take color in photography for granted. Answer some questions, before reading my comments, and then ponder the latter.

1. What is the ASA rating of the color film(s) you use? Why do you like the film(s)? What sort of color qualities do they give you?

Author's response: People become partisans of a particular color film as they would a camera or a perfume. That's fine if they realize that a fast film offers less contrast, while slower films with more contrast also give you deeper, richer colors. Kodachrome has long been a favorite slow color film, though sometimes I find its color rendition unrealistic.

An ASA 400 film can be as restricting as an ASA 25 film in opposite picture situations. The slowest film may handicap you in requiring a tripod when none is handy, while the fastest film makes it awkward to stop down far enough with bright sun or close flash, thereby requiring a neutral density filter.

Compromise on speed with an ASA 80 or ASA 100 film. Most of the pictures in this chapter were taken with Eastman 5247 rated at ASA 125.

2. Are there some pictures in this chapter (without reading captions) for which ASA 100 or ASA 125 seems inappropriate?

Author's response: I could have made the photograph of Chicago at twilight with a faster film. I didn't use a tripod, and the 1/4 sec. exposure shows camera movement. But the effect seems excusable because Chicago is decorative at twilight.

The photo taken in the Louvre could have been taken more conveniently on a faster film as well. Some blur due to subject movement is evident, but a little blur isn't objectionable here either. However, an ASA 400 film would have been a lot more comfortable to use.

3. What do you think of as unusual color effects or characteristics?

Author's response: In formal color theory, which you may enjoy investigating, there's a natural spectrum of colors taken from the rainbow. We expect to see color related as nature paints it, and when the order is upset, it's called a reversal of the natural order of values.

We expect to see bright warm colors and more subdued cool ones, so a bright blue next to a dull orange can be startling. Subtle colors surrounding a bright one also attract the eye. The unusual has an emotional impact, even if it is occasionally not welcome.

Action — Sharp and Blurred

You can tell when you're becoming a more serious photographer. You find yourself more concerned about the topics in this book and how they'll affect your pictures. You instinctively integrate depth of field, composition, and color into your pictorial thinking, and you're ready for the nuances of photographing action. Why?

Because your timing has improved, and you're better able to distinguish telltale camera movement from subject motion in prints and slides. In addition, you're probably experimenting more, which means testing theories and practice discussed in this book. This is still a *Workbook* with the accent on *work*, and hopefully you're not just sitting there lethargically.

As you study the illustrations showing various kinds of sharp and blurred action, make a category list for yourself, of parallel shots to take. While good and bad comparison shots are not included in this chapter, I had failures to match your own. You learn from mistakes because they help you understand what is supposed to happen with the controls you have at your shutter-fingertip. Later, when facts and images coincide successfully, little mysteries about action photography are eliminated.

FAST SHUTTER SPEED OPTIONS

What's the fastest shutter speed on your camera? When did you last use it, and for what?

If your camera's top shutter speed is 1/500 sec. or 1/1000 sec., there are hardly any everyday activities that you cannot

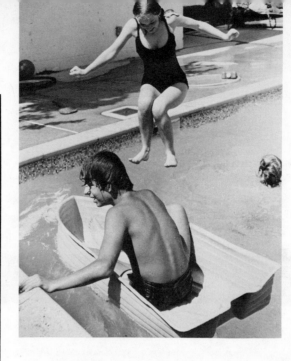

6-1. Mid-air sharpness was accomplished at 1/1000 sec. and a 50 mm lens from close by.

photograph sharply. Speeding bullets and zooming insects require much higher speeds, like 1/10,000 sec. accomplished with electronic flash, but sports events, kids playing, and fleeting expressions can be *stopped* or *frozen* by the average 35 mm or medium-format camera shutter in most circumstances. Following are the elements, individually or combined, that make fast shutter speeds possible and worthwhile.

Light. It has to be intense enough to permit a fast exposure that records action sharply on film. Sunlight, open shade, bright indoor illumination, and electronic flash are all suitable for fast-action photography. Photo 6-1 was easy to shoot at 1/1000 sec. in summer sun. It could also have been shot at 1/500 sec., though the leaping young lady may have blurred a bit. The camera was loaded with Tri-X (ASA 400), which made using $f/16$ on the 50 mm lens almost inevitable since few such lenses stop down to $f/22$. This represents a light/film squeeze, and ways to avoid it are discussed below.

Film. You don't need the fastest film to shoot fast action. Photo 6-1 could have been taken more comfortably on slower ASA 125 or ASA 80 films, for instance. Translate $f/16$ and 1/1000 sec. for Tri-X to the necessary f-stop for an ASA 100 film (between ASA 80 and ASA 125), and the answer is an $f/8$ lens opening. Why would this have been just fine for photo 6-1?

Because at $f/8$ there would still be enough depth of field with the 50 mm lens to assure sharpness from the foreground to behind the flying lady. Further background sharpness is superfluous here, which leads to a simple conclusion: Choose film speed to suit your subjects and the type of light in which you generally shoot. Become familiar with the characteristics of a slow film or a medium-speed film, plus a fast film. The slower the film, the greater its inherent contrast; for instance, Kodachrome (ASA 25) or Plus-X (ASA 125) are more contrasty than Tri-X (ASA 400) or Ektachrome 400. The lower contrast

of fast films is often fine in bright sun, and their speed is useful for shade and indoors; but high ASA ratings may make small f-stops necessary, whether you want them or not.

ND filters. A handy antidote to the fast film squeeze is to use a neutral density filter, like a 2× or 4×, which halves or quarters your effective film speed, respectively, *without* affecting color. Thus, you may shoot with an ASA 400 film and a 2× ND filter at 1/1000 sec. and f/11 in bright sun, and have more control over background sharpness.

Direction of the Action

The angle at which people or things approach your camera influences the success of action photography. You can anticipate sharpness to a large extent when you know the action is coming toward the camera, or moving diagonally, or straight across the scene.

Photo 6-2 was taken in a well-lighted auditorium by Howard Castleberry who won a Kodak/Scholastic Award for his exciting basketball shot taken on Tri-X rated at ASA 1600 (he used a special high-energy developer to boost film speed). Howard's SLR was equipped with a motor drive and a 135 mm lens, and he shot at 1/500 sec. and f/4. The fast shutter speed was aided by this principle: Action coming toward or going away from the camera covers less ground than action moving across the film plane, and less blur can be expected than when you shoot subjects moving more or less perpendicular to the lens. Even at 1/250 sec., photo 6-2 might have shown acceptable sharpness. Here are some other things you may conclude about photo 6-2:

— Using a telephoto lens gave Howard a larger image that is reproduced with minimum cropping. However, in less

6-2. Howard Castleberry shot action coming toward his camera, equipped with motor drive, and was able to get a sharp image indoors because ... Draw your own conclusions.

than brilliant light levels, most telephotos are limiting because of their $f/3.5$ or $f/2.8$ maximum aperture.

— Howard therefore boosted his film speed to make using the telephoto feasible. Color films such as Ektachrome may also be rated at higher ASA numbers when you use a custom lab or Kodak boosted film processing.

— A motor drive on an SLR makes sequence photography possible, so Howard could shoot perhaps four or five frames as the players approached. The trick here at a relatively wide aperture is to keep the subjects in focus consistently. A motorized camera or use of an auto-winder is a definite asset in action photography, providing you do not depend on luck rather than instinctive selection of peak action moments. With a motor drive or auto-winder, you can concentrate on action and focus without removing the camera finder from your eye to wind the film.

Now consider photo 6-3 in which the car crossed the scene and blurred at 1/250 sec. Even at 1/500 sec., a car this close moving at 30 miles per hour would have blurred, but had it been traveling in a diagonal line, the image might have been acceptably sharp, depending on how far away it was when the exposure was made. This brings up another principle that affects action photography: The closer the subject, the greater the distance it will travel during the instant the shutter is open. A car 100 feet away and moving across the film plane would have been much sharper at 1/250 sec.

Exercise in Three Shots

Ask someone to run or ride a bike in three separate directions as you shoot: (1) coming toward you, (2) approaching diagonally, and (3) crossing in front of you. Shoot each direction at

6-3. Crossing the scene, a moving object blurs easily, though this car in Houston was not moving very fast.

least three times so you can vary shutter speed from 1/125 sec. to 1/500 sec. or 1/1000 sec. as you wish. Keep notes about your exposures, and later check the slides or prints to compare both blur and sharpness at the varied shutter speeds. From this exercise you'll see clearly the relationship of shutter speed and the direction of action, and you may even try close and far versions of angles 2 and 3 to see the difference.

PEAK ACTION

Peak means the top of, and it usually refers to an up and down, or in and out, movement, or series of movements. Watch a basketball player leap, heave the ball, and come back to the floor on his feet. As his jump reaches its peak and the ball leaves his hand, the action peaks; in the next millisecond, the player begins to descend. Think about peak action as you've watched it in tennis, baseball, hopscotch, and many other activities. Thus, you will realize that photographing action as it peaks gives you the ultimate in visual drama much of the time, and allows you to shoot at somewhat slower shutter speeds than you might otherwise need, because at its peak, action is slower.

Photo 6-4 was exposed at 1/500 sec. when the young lady's somersault reached its zenith, and her feet began their return to the mat. The lens was a 135 mm telephoto, so I could keep my distance. The young lady's feet and hands would have been sharper at 1/1000 sec., but a limited amount of blur often symbolizes action better than complete sharpness.

Catching action at its peak really pays off in the shade or indoors when shutter speeds from 1/60 sec. to 1/125 sec. are

6-4. At the peak of her somersault, the young lady's action was exciting to photograph. Blurred feet symbolize action nicely.

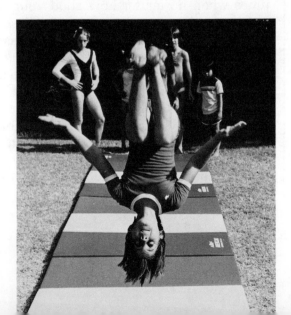

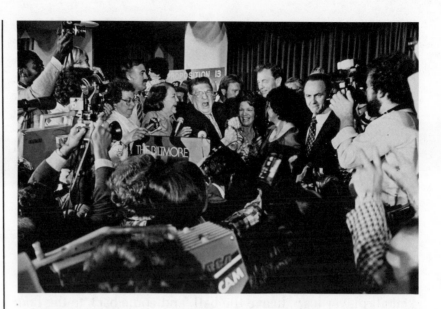

necessary. Photo 6-5 demonstrates this beautifully. It is a news picture taken by Jimmy Townes during a political campaign in California when the man in the middle, Howard Jarvis, seems to be shouting victory for his "Proposition 13." All around Townes electronic flashes were going off, but he disdained that one-directional light in favor of shooting at 1/60 sec. with Tri-X rated at ASA 400. Television lights allowed Townes to set his 35 mm lens (on a 35 mm SLR camera) at $f/5.6$, and the result is a sense of place and reality as well as adequate sharpness in the picture. The many facial expressions caught at their peak, unblurred, were possible through careful timing in a difficult situation.

Electronic Flash

Shooting action at relatively low shutter speeds requires a steady camera and precise visual judgment, and the result is adequate sharpness plus believability. However, there are times when no matter how good your timing, existing light won't do, so you turn to electronic flash—the light noted for its action-freezing capability, flashing as it does at 1/1000 sec. and faster. Your shutter speed, set at 1/60 sec., or even 1/125 sec. on some cameras, merely guarantees that the shutter is wide open on the "X" synchronization.

Flash can be a blessing, but I prefer shooting with natural light if possible, even if there's occasional blur. I know that flash photography requires the same instinct for peak action and a quick sense of composition that you need without flash. Practice shooting action with flash as extensively as you wish, to feel more sure with its techniques.

SLOW SHUTTER SPEED OPTIONS

When a picture isn't sharp, there are several possible reasons you might consider:

1. The lens was not focused correctly.

2. Focus was sharp somewhere in the picture, but lens depth of field failed to carry into other important areas.

3. The camera was jiggled, even slightly, as the exposure was made. Hand an inexperienced person your camera to photograph you, and watch as his or her index finger may jar the whole camera as the shutter button is depressed. Learning to hold a camera steady, and to hold your breath as you shoot, is basic to good technique. When an entire image is not sharp, camera movement is to blame. By comparison, if a camera is steady, and you shoot at a slow shutter speed, only moving objects will blur.

4. The shutter speed was too slow for the action or movement of people or objects in the scene, and they blurred.

Intentional Motion Pictures

Photos 6-6 and 6-7 demonstrate blur in a way I don't recommend, mainly because they should have been taken from a tripod, and mine wasn't handy. It was dusk at a Long Island station where photo 6-6 was taken with a handheld SLR at 1/15 sec. and $f/4.5$ using a 50 mm lens. The film was Plus-X and the lens was stopped down to $f/4.5$ for sufficient depth of field.

As the train pulled out moments later, I shifted position slightly to brace myself against a pole, and exposed photo 6-7 at 1 second between $f/11$ and $f/16$ (it was getting darker). Obvious camera movement could have been prevented had I used a tripod, but the dramatic blurring of the train would

6-6 and 6-7. The same train parked and moving. Planned blur is explained in the text.

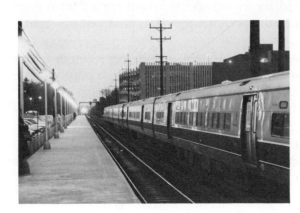

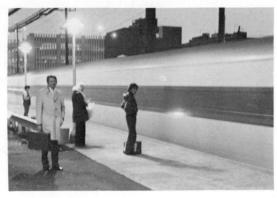

have looked the same. Blur helps to stamp out reality to some degree, though you're never quite sure of the visual effect until you see the slides or prints.

As an exercise, try some similar pictures of moving cars, trains, planes, or people. Use a tripod, or brace the camera in a substitute way if you must. Shoot at a series of shutter speeds, and keep a record so you can duplicate blurred effects later. If you make exciting discoveries, because slow shutter speeds produce superlative aesthetic effects sometimes, the *Workbook* will have been worth its price. In color, action or movement blurs in unique ways that you cannot duplicate precisely, nor will anyone else shoot exactly the same pictures. Continue to experiment with slow shutter speeds in low light levels and at night, because something new is always happening on film as you change situations.

Slow Speed Requirements

In bright daylight, it is almost impossible to shoot at slow shutter speeds, even with the slowest film, unless you use a strong neutral density filter to reduce effective film speed. When there is less light intensity indoors, at dawn, at dusk, or at night, you can slow the shutter down. Here are some specifications for having fun with intentionally blurred images:

— A slow or medium-speed film allows you to shoot at more slow-speed options. For a compromise, film rated between ASA 64 and ASA 125 gives you flexibility.

— Blur begins to show for average subjects at shutter speeds slower than 1/30 sec. Your own tests will reveal how slowly you can shoot and still recognize the subject. At 1 second, a person or object can easily lose its identity, as did the train in photo 6-7. From 1/2 sec. to 1/15 sec., blur patterns are often pleasing. Deciding which speed is best comes from your experience with the subject that's moving, how fast it's going, and in what direction.

— Pictorial possibilities increase with your camera on a tripod, because there's a definite contrast or separation between sharp subjects and those that blur.

Photo 6-8 is another slow shutter speed example to illustrate the beauties of blur. The picture was taken along Manhattan's Fifth Avenue at dusk, again without a tripod because none was available. The film was Plus-X (ASA 125), and the 35–70 mm zoom lens was set between 35 mm and 50 mm. Exposure was 1/8 sec. at about $f/3.5$, the widest aperture of that

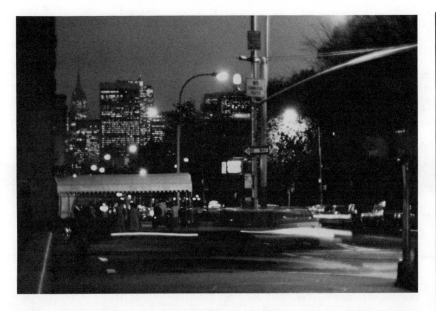

lens. My back was braced against a wall, and I made half a dozen exposures of the same scene where only moving traffic and people varied. I knew the overall picture would not be completely sharp, but its softness seems appropriate to the blurring lights that symbolize a city at late dusk.

Zoom Blurs

Another way to enjoy intentional blur effects at slow shutter speeds is with a zoom lens, where you zoom the lens *during* the exposure. A tripod is highly recommended for this, though occasional handheld shots are successful. Here are some directions for experimenting:

— You need a dim light situation that permits slow shutter speeds. Any film that makes possible 1 second and 1/2 sec. exposures is suitable.

— Plan the picture, shoot at 1 second or 1/2 sec., and zoom the lens as smoothly as possible during the full exposure. You need time to twist the lens or manipulate its push-pull zoom. Focus should be preset but is obviously not of main importance.

— The more dynamic the action, the greater the zoom blur. Photo 6-9 was taken at an indoor basketball game when the referee, in dark pants, was receiving the ball from a player. The lens was a 65–135 mm zoom on an SLR loaded with Tri-X. Exposure was 1/2 sec. I tried a longer exposure, but there was even less definition of the moving players in that shot and the image was mushy.

— The longer the exposure, the more pronounced the zoom effect, as illustrated by photo 6-10. What caused the long

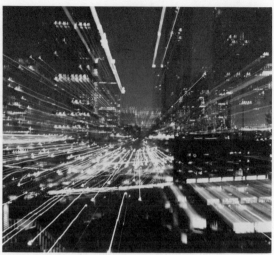

6-9. A 65–135 mm zoom lens was zoomed during a 1/2 sec. exposure at a basketball game. The result is almost an abstract pattern where players lose their identity.

6-10. Only a long exposure while zooming a lens will give you extended light streaks like this. It was exposed about 15 seconds with an 80–200 mm lens on a 35 mm SLR which was mounted on a tripod.

light streaks? It would not be feasible to achieve a zoom pattern such as you see in photo 6-10 in 1 second, so it is evident the long lines of light were produced by an extended exposure—in this case 15 seconds arrived at by educated guess. The 80–200 mm zoom lens was stopped down to $f/8$, and the SLR loaded with Plus-X film. Exposures from 10 to 30 seconds were made, all at $f/8$. (In the next chapter, you will find out more about judging the lights at night, which are not as bright to the film as they may appear to the eye.)

Photo 6-10 reveals, especially at bottom right, that the lens was zoomed slowly and that zooming action stopped momentarily about halfway through the interval. Since there is a 120 mm span in the 80–200 mm zoom, and the zoom ring was turned consistently but slowly, the light streaks are elongated. However, a zoom lens with a shorter span can be made to produce a similar effect by planning a slow zoom over a long exposure, especially of a subject with lights in it at night.

— Whether you zoom the lens from far to near, or the reverse, seems not to matter with some subjects, but it is advisable to experiment in both directions. In addition, zoom quickly and fully for some pictures, and less quickly but not all the way for others. It is annoying to make notes under zoom-blur circumstances, so try to remember what you did for specific shots.

The effects you get while zooming during exposure are dependent upon serendipity, which means that proper preparation leads to predictable accidents.

Exercises

To complete this chapter on photographing action and moving subjects, here are some case history pictures to help illustrate the beauty and the emotional impact we often hope to get on film with average and unusual subjects. Whether you freeze or blur movement, success can be satisfying. Your sense of timing is challenged by each technique, and when you anticipate peak action effectively, the storytelling quality of pictures improves.

Some of these images involved principles already discussed, and some offer additional aspects of action photography. Visual effects in each photograph are questioned. *Write your answers and do not revise instantly after you read my observations.* Your responses need not be identical to mine, as long as the basic reasoning is similar.

Photo 6-11: A large gull took off from a piling next to a lagoon, and I waited for this moment with the camera shutter speed set at 1/1000 sec. Why was that not fast enough to freeze the bird's movement? How is focus or depth of field involved?

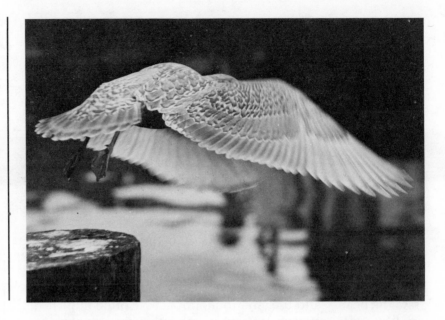

6-11. A gull in motion, moments after lifting off the piling, is only partly frozen in a fraction of a second. Questions about this and the following photograph appear in the text.

Photos 6-12 through 6-16: Sequence photography of sports and other events is stimulating with or without a motorized camera. You see it most often in sports magazines, or where a series of editorial portraits accompany a magazine or newspaper article. Since an auto-winder for a 35 mm SLR has become relatively inexpensive, sequence picture-taking is more accessible to the average photo hobbyist.

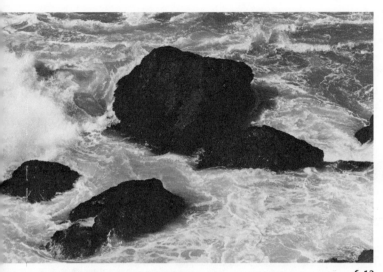

6-12

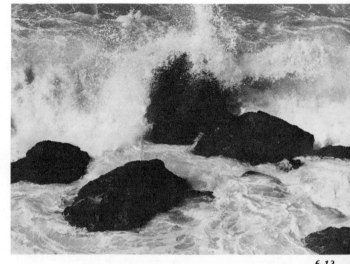

6-13

6-15

6-12 through 6-16. This sequence of surf on rocks is integrated by several things, but one of the pictures may not belong. Study the series and pick the odd one out.

6-14

6-16

Photos 6-12 through 6-16 were shot from a low cliff along the Oregon coast but could be duplicated anywhere you find moving water or other motion phenomena. One specification helps to tie these pictures together and make the series more dramatic. What is it?

Photos 6-13 and 6-14 are alternate midpoints between the approaching water in 6-12 and the closer waves in 6-15. Compare 6-13 and 6-14. Which seems the better link in the series? Which has more aesthetic appeal for you? In answering, consider whether 6-13 or 6-14 seems more appropriate in relation to 6-16 as the final image.

Photo 6-17: This delightful winner of a Kodak International Newspaper Snapshot Award was taken by Paula Marie Elston. Does it look posed or candid? Were the people models, or was it snapped after an actual wedding? What else can you tell about Paula Marie's action-shooting technique?

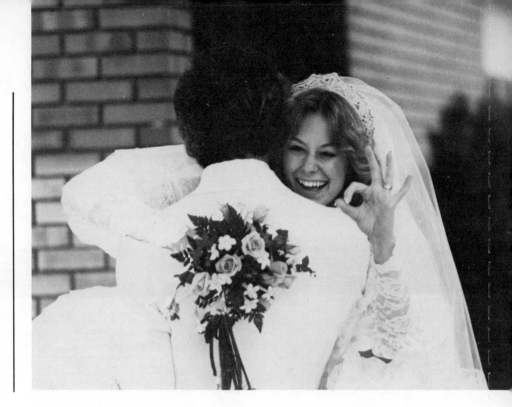

6-17. *Can you believe that this picture was posed? Do the people look authentic?*

Photo 6-18: Aesthetic action situations are not as common as those you shoot to simply tell a story or show a game in progress, but it is fulfilling to find them. This is another KINSA winner taken by James B. Currie. Of this sunset silhouette in black-and-white, judges admired touches such as "the movement of the net" and the dramatic lighting that creates "almost a theatrical motif." What can you determine about the photograph from a technical viewpoint?

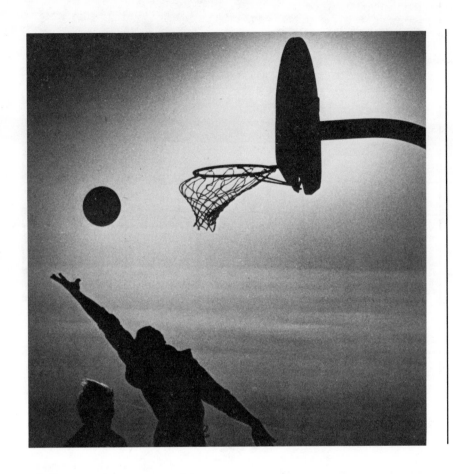

6-18. James B. Currie won a KINSA prize for his silhouette action photograph. Through proper exposure, high contrast can be pictured without shadow detail.

6-19. A candid photograph means one that is unposed or, if posed, the picture looks natural. Kids don't pose well and are therefore excellent subjects for action photography, sharp or blurred.

Photo 6-19: Here's a domestic action shot of a youngster at play. What shutter speed might have been used indoors with an ASA 400 film? What can you tell about the lighting? What does the word "candid" mean to you in terms of photography?

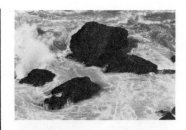

6-12

6-13

6-11

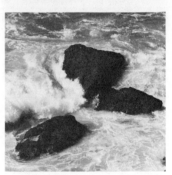

6-14

6-15

6-16

Author's Responses

6-11: The gull's movement is across the film plane, and the wings move swiftly, causing the most blur at their ends where motion is greatest. There was also a minimum of camera shake because I was startled, even though the camera was focused and ready. Finally, the 200 mm lens was focused at perhaps 10 feet, and background water reflections are soft due to minimum depth of field.

6-12 through 6-16: What ties the pictures together is the uniform composition format which indicates the series was taken from a tripod with a consistent point of view.

Photo 6-14 seems the more logical choice for the sequence because the water is coming around the rock to better match the surf seen in 6-15. Photo 6-13 has aesthetic merits of its own, and was actually part of a separate series. Photo 6-16 seems more realistic at the end of a sequence that runs 6-12, 6-14, 6-15, 6-16.

Whatever subject you choose for a series, it is your timing that is most important. The moments you choose to snap the shutter will give your images individuality. Some actions demand a fast sequence, while other subjects, like the moving surf, permit you to space your exposures a second or two apart. Try variations, and make additional discoveries for yourself.

6-17: Here's the caption that accompanied this picture titled, "Got Her Man": "Paula Marie Elston snapped this winning shot of friend and former co-worker Valerie Purdy Williams and 'her man'—Ron—on their big day. Said Ms. Elston, 'She posed, I shot and we both knew it would turn out great.' Added the contest judges, 'It tells a tremendous story with a touch of whimsy. It captures the human spirit!'"

No, the picture doesn't look posed, which nicely illustrates how you may set up action pictures by directing people

105

6-18

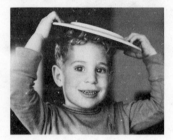

6-19

to do things they might do anyway if you weren't there; you can then shoot the activity which has a sense of unposed reality. When people are supposed to be interacting, tell them to be animated and say what they please because you don't have any sound track to worry about.

A further note about photo 6-17: it isn't completely sharp, probably because Paula Marie was naturally in a rush which caused minimum camera movement. In addition, the original is in color, and conversion to black-and-white sometimes alters definition slightly.

6-18: No technical data came with the picture, so my guess is that shutter speed was 1/500 sec. or 1/1000 sec. because of the way the arm, ball, and net are frozen. The background looks like sky, or perhaps the sea is suggested along the coast. Currie cleverly shielded the sun behind the bounce board and used an exposure guaranteed to create a silhouette. The effect was amplified by darkening the top corners of the print.

6-19: It seems obvious that light came from a large window or glass door at the left or left front of the child. The indoor exposure may have been 1/125 sec. or 1/60 sec. at f/3.5 or f/4, which accounts for the soft background where depth of field didn't carry.

Children provide some of the most rewarding—and frustrating—action-picture opportunities that you can capture on film. Your sense of timing and patience are both challenged severely, and when the existing light isn't bright enough, tracking a child with electronic flash offers most of the same problems, except you don't worry about subject movement. Practice your skills with kids, and you'll be in training to shoot all sorts of action with greater ease.

Available Light and After Dark

Most of you have probably struggled with composition and depth of field at some time, and experimented with color and action as well. But available-light photography and time exposures after dark may not be as familiar because they are often considered intimidating subjects. When there's "not enough light" (sometimes an emotional reaction not based on facts), or darkness has fallen, people too often put their cameras away or reach for flash units. You might say they're afraid of the dark, in a photographic way; afraid of poor exposures, and not eager to shoot where meters are stretched to or beyond their limits.

Information and exercises in this chapter are aimed at helping banish your apprehension if you're reluctant to shoot when the light is dim, or at night. Experience gained with slow shutter speed options in Chapter 6 will give you a head start. Comparison pictures should stimulate and guide you, and answering the questions can help direct your self-training efforts. Feedback comes from questioning yourself, because dim-light and time-exposure images can be *very personal*. Your pictures won't be fully predictable, and what you get may inspire you to experiment further. Other people may not see the visual or aesthetic possibilities that you do.

You must be objective and critical about your own images, but be liberal at the same time. From near-miss pictures may emerge real triumphs when next you try the same type of photography. Prepare to take some risks, and to wipe out some picture-making inhibitions.

AVAILABLE LIGHT

Available light is also called *existing* light or *ambient* light. These are interchangeable terms that refer to limited-intensity lighting conditions which make ordinary photography diffi-

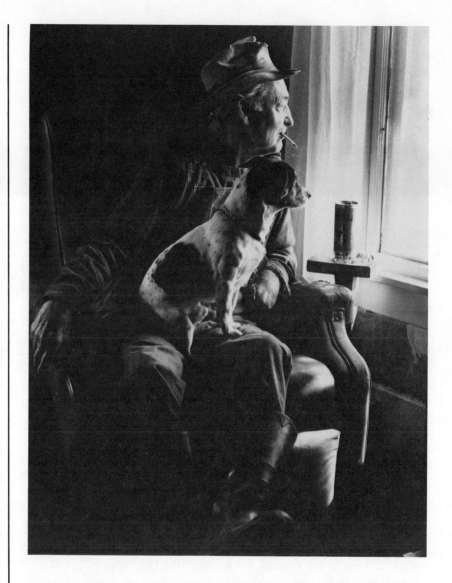

7-1. At first glance you may have thought, "Not a hard picture to take with daylight coming through the window," but would you have seen it this way? There's always the temptation to brighten shadows with flash or floods, even though available light may be perfect for the subject. Coed Marcia Joan Maloy asked her friend Cecil Neal to look out the window from his favorite chair. Passing children caught his eye as she snapped the picture that won her $2,500 in the Kodak International Newspaper Snapshot Awards. Judges admired the "color" Marcia achieved through fine black-and-white tonal gradations. Sidelighting is often very pictorial when shadow detail is secondary.

cult. Can you anticipate how some of your usual techniques are strained in low light levels?

These points should be part of your response:

1. You have to shoot with near-maximum lens apertures that provide very little depth of field.

2. Slow shutter speeds make camera shake and blurred subjects a definite risk.

3. You're better off with a high-speed film, but you're more comfortable with medium- and low-speed films.

A "strained" exposure would be 1/30 sec. at $f/2$. Why? Because those specifications are near the limits of practical hand-held exposure. To hold a 35 mm camera steadily at 1/30 sec. takes experience, and at 1/15 sec., you need luck as well to avoid noticeable camera movement. If you think slides or

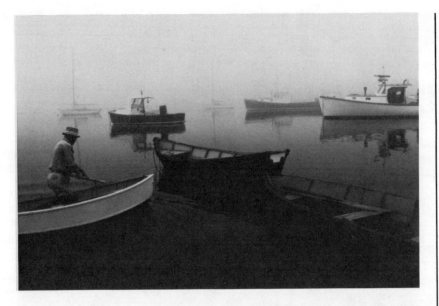

7-2. Available light need not always be harsh as this misty view of a Massachusetts marina shows. It was a KINSA winner in color by Bruce Christian Pierce, and the judges raved about "the somber mood sparked by the fairly raw, bright colors of the foreground boats."

negatives look sharp when taken at 1/30 sec., enlarge them and check again. Don't be surprised to find evidence of camera shake. A really sharp picture at a relatively low shutter speed is a surprise. A test to help demonstrate your steadiness appears at the end of this chapter.

A lens itself may contribute to lack of sharpness when used wide open (at maximum aperture) or close to it. While a majority of today's lenses make acceptable images wide open, they are sharper when stopped down, and most lenses for 35 mm cameras are sharpest somewhere between f/4 and f/8.

Forget the Limits

With the above in mind, should you try to avoid shooting in light so dim that the lens has to be at full aperture and the shutter speed set at 1/30 sec. or slower? It can be uncomfortable to work in such circumstances, but when it is inevitable, when no other light is available, and when there are worthwhile pictures at hand, *do it.* A large number of terrific pictures have been taken between f/1.4 and f/2.8, especially when a shutter speed of 1/60 sec. or faster was possible. Focus carefully, make the most of out-of-focus backgrounds and perhaps foregrounds, and concentrate on what are often real human situations.

Ideally, when a subject is not moving in dim light, you can use a tripod, a slow shutter speed, and a stopped-down lens. But if that isn't feasible, just ignore the limits that affect image sharpness, because the pictures you want are important enough to give them priority over more practical technique.

With foresight, you can use a fast film (ASA 400) and even boost the ASA with special development, in order to

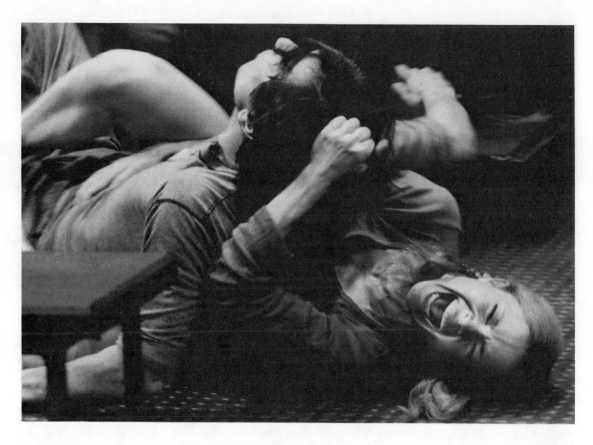

7-3. An exciting available-light photograph by Jimmy Townes.

meet dim-light situations with more competence. Work with an f/1.4 or f/1.8 lens rather than an f/3.5 model when you can. I had to shoot a coral reef from a glass-bottom boat, and chose a 50 mm f/1.4 lens so that I could expose at f/2 and 1/60 sec. (with ASA 125 film), rather than depend on an f/4 lens with a preferably longer focal length. Perhaps 1/60 sec. doesn't sound very daring, especially when people are not in fast action, but when you can only clamp your elbows to your sides and hope to breathe properly, using 1/60 sec. often requires steady nerves and constant alertness to catch peak activity. Expect to find plenty of blurs between the frames with sharp images.

Photo 7-3 is an outstanding example of photographic daring that paid off. Jimmy Townes photographed a play rehearsal where stage lighting was barely adequate, and many dramatic moments in the story were very active. In this photo, two characters in the play tussle in a moment of high drama, and it was taken at 1/60 sec. and f/2.8 using an 85 mm lens on a 35 mm SLR camera. Jimmy used Tri-X rated at ASA 1200, and chose the 85 mm lens in order to stay out of the way and because of its maximum aperture.

How bright is *dim* light? Set your exposure meter (in your camera or otherwise) at ASA 400 or ASA 1000, and point it

110

around a dimly lighted room, restaurant, or the like until the meter indicates 1/60 sec. at $f/2$ or $f/2.8$. This is the amount of light with which Jimmy Townes had to work. He chose not to use flash, which would disturb the character of the actors and their setting, and preferred to chance catching those fleeting moments of peak action. He shot a lot of film, realizing he'd get quality from quantity. That doesn't mean trusting just to luck; it means calculated risks, some of which you know will pay off.

Certain combinations of light intensity, subject movement, and shutter speed are inevitable in ambient lighting, and when your controls are limited, try not to worry about a little blur. It actually enhances an image like photo 7-3. Each time you make an exposure, have a specific visual reason, no matter how minor. Each shot can be part of a whole story, and you cannot be sure which images will eventually stand alone. You'll find that in difficult lighting, self-imposed limits are the ones that are best ignored.

Indoors/Outdoors at Night

Photography after dark does *not* automatically require time exposures, by which I mean the use of shutter speeds that cannot be practically handheld. I've set 1/30 sec. as the safety limit, but you're invited to practice at slower handheld speeds. Look for lighted streets such as the one illustrated in photos 7-4 and 7-5, and strain whatever limits you may be feeling. You won't be held accountable for any specific pictures; you'll be shooting personal impressions, or reporting what you see, and in either case the goal is after-dark practice.

Photos 7-4 and 7-5 were both made with an $f/1.4$ 50 mm lens on Tri-X rated at ASA 1000 and developed in Acufine.

7-4. With the lens set between f/2 and f/2.8, depth of field in this night shot is limited, but the scale of tones is quite suitable.

7-5. A different view of the same cyclist in photo 7-4, taken at a slower shutter speed.

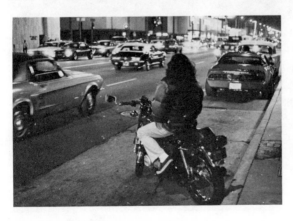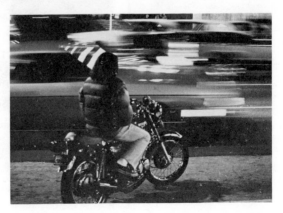

While I was prepared to shoot wide open, the meter indicated an exposure between $f/2$ and $f/2.8$ at 1/60 sec. for photo 7-4. But, you may ask, why that exposure with all those bright lights?

Briefly, a meter is designed to *average* the light reflected from a scene into a middle gray tone, called an 18 percent gray. Ask to see a gray card sold in camera shops, and you'll be holding that precise 18 percent middle gray in your hand.

Relating the above to photos 7-4 and 7-5, the built-in camera meter viewed bright lights plus pockets of darkness, and in its inexorable way, it averaged them to an exposure for 18 percent gray. That is why you see detail in shadows which would be absent if you exposed only for the highlights. A variety of tones are visible to the eye, of course, but our eyes can vary their ability to see detail to a greater extent than an exposure meter and film are able to do. The camera meter must supply a single exposure for each shutter click, and it is sometimes a compromise.

For photo 7-4, 1/60 sec. was fast enough to slow the cars to a moderate blur; the cyclist is sharp because that is where I focused. Photo 7-5 shows long streaks where cars passed, indicating a much slower exposure (1/4 sec.) and a smaller lens opening (about $f/8$) that resulted in the people across the street being sharp. The camera was braced against a pole to allow the slow shutter speed.

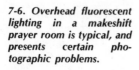

7-6. Overhead fluorescent lighting in a makeshift prayer room is typical, and presents certain photographic problems.

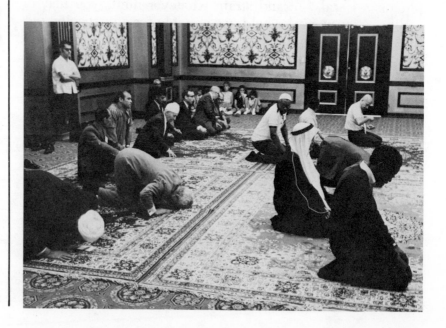

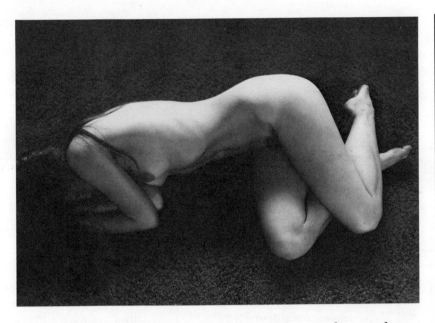

Indoors. Light levels indoors are often as low or lower than you find outdoors at dusk or at night. Many rooms are lighted with lamps that create pools of light, so exposures will vary according to the proportion of bright light and relative darkness the meter reads. As you've noticed, when shadow dominates, light areas may be overexposed, and vice versa. Experiment with brightening shadows with floodlights or bounced flash, but remember that confidence in existing light gives you versatility.

Photo 7-6 was made in an improvised prayer room at a hotel where religious meetings took place, and I was there to do a magazine story. The setting is typical in its even overhead fluorescent illumination found in so many offices and public places. Using black-and-white film rated at ASA 400 or higher, you can shoot at 1/60 sec. and f/4.5 approximately. There's less shadow detail than I prefer, but the prayer rugs reflected little light into faces, and adding flash would have been objectionable.

When you have to take color pictures under fluorescent lighting, you may have to depend on a certain amount of correction by the printer. Otherwise, use an FLD filter (with daylight film), which reduces effective film speed considerably. The FLD filter helps eliminate the green pallor caused by fluorescents, but in many cases you cannot use it effectively without a tripod, since exposures are so slow. It is also preferable to use flash sometimes, rather than settle for distorted color caused by fluorescents.

Photo 7-7 was also taken in an available-light situation using daylight from a high window behind the model, though

a similar effect could be created with diffused floods or flash. I shot from a low ladder with a 35 mm lens on my SLR, which was loaded with Plus-X. Exposure was 1/60 sec. at $f/4.5$. Another window in front of the model supplied a much weaker light to fill the shadow side of the model suitably.

It takes courage to shoot in some kinds of existing light, but the visual rewards are worth it.

TIME EXPOSURES

A Century Ago

Just to make you feel better about modern photo equipment and materials, and as a fascinating footnote, photo 7-8 opens this section. In 1885 when these performers at a Mexican acrobat show posed for an unknown photographer using a film or plate about 5″ × 7½″, cameras had shutter speeds as fast as 1/100 sec. The widest lens aperture was about $f/3.5$, and portrait photographers used diffused daylight from windows or a skylight. In present day terms, the film or plate for this picture was probably between ASA 2 and ASA 5.

We can only guess at the exposure, which could have been 3, 4, or 5 seconds, long enough for the intruder at the right to blur and the hanging sheet at the left to stir. The subjects stood very still and their eyes stared steadily ahead. Nevertheless, the photographer triumphed under conditions we would find handicapping.

Time exposures are easier today. With experience, you can predict success fairly often, although taking risks leads to the delights of serendipity.

7-8. Taken in 1885 with a plate camera and slow shutter speed, this antique group portrait has character. It is discussed in the text.

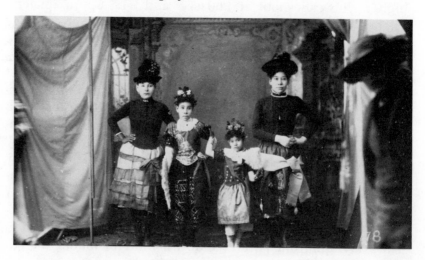

One Second and Longer

Though some camera shutters can be set for from 2 to 60 seconds, and can time long exposures automatically, it has been determined that a time exposure is generally a half second or longer—beyond a sensible handheld limit. It has also been shown that time exposures produce unpredictable images sometimes, which can be frustrating if blur ruins a picture, or pleasing when blur is a pictorial asset. Often the primary picture-taking problem with time exposures is determining the correct exposure, so let's take care of that with the accompanying chart.

AVAILABLE LIGHT EXPOSURES

Type of Subject	f-stop at ASA 25	f-stop at ASA 100	f-stop at ASA 400
Brightly lighted stage or auditorium shows and stage shows	1/60 sec. at f/2 to f/2.8	1/60 sec. at f/5.6 to f/8	1/125 sec. at f/11 to f/16
Bright signs, street scenes, display windows	1/60 sec. at f/1.4 to f/2	1/60 sec. at f/2.5 to f/3.5	1/125 sec. at f/4.5 to f/6.3
Brightly lighted home, office, store interiors	1/30 sec. at f/1.4 to f/2	1/60 sec. at f/2 to f/2.8	1/125 sec. at f/2.8 to f/4
Night sporting events on floodlighted fields	1/15 sec. at f/1.8 to f/2	1/60 sec. at f/1.8 to f/2.5	1/125 sec. at f/2.5 to f/3.5
Fireworks, lightning, Ferris wheels	1 second at f/5.6 and bracket	1/2 sec. at f/8 and bracket	1/2 sec. at f/16 and bracket
Gyms, auditoriums	1/8 sec. at f/1.8 and bracket	1/30 sec. at f/1.8 and bracket	1/60 sec. at f/2.5 and bracket
Floodlighted water fountains or monuments; for colored or dim lights, open one stop more than recommended	1/2 sec. at f/2.8 and bracket	1/2 sec. at f/5.6 and bracket	1/2 sec. at f/11 and bracket
Outdoor lighted Christmas trees; close-ups by match or candlelight	1 second at f/2.8 and bracket	1/2 sec. at f/4 and bracket	1/4 sec. at f/5.6 and bracket
City skylines with scattered window lights	12-20 seconds at f/2.8	3-6 seconds at f/2.8	2-4 seconds at f/4.5
Full moon over a landscape	1 minute at f/2.8 and bracket	15-20 seconds at f/2.8	4-8 seconds at f/2.8

f-stops should be bracketed because these nighttime subjects are of varying intensity. Even if your meter seems to give a satisfactory reading, shoot at several different exposures to offset the influence of excessive bright lights or larger areas of darkness. For films whose ASA speeds are not listed, calculate from the given recommendation. For films with related ASA speeds, such as ASA 125 rather than ASA 100, ignore the difference as it will be absorbed by other variables.

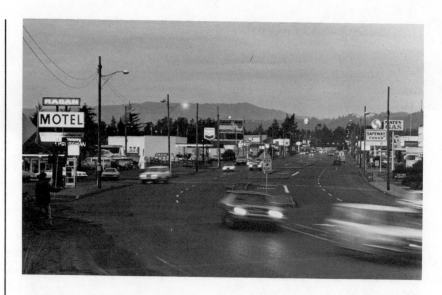

7-9. Refer to the text for questions about this dusky photograph.

Adjust shutter speeds to achieve more or less blur. A moving car at night will produce a streak of light that is longer at 1/8 sec. than at 1/30 sec., but motionless surroundings will appear about the same at either speed, providing *f*-stop is set correctly. When using a tripod, stop down beyond the recommended aperture, and adjust shutter speed accordingly, if conditions permit.

EXPERIMENTS AT NIGHT

If you haven't experimented with photography after dark, wait no longer. Take a tripod and a camera loaded with your favorite film, and choose a location or two for experimenting. Since you won't be trying to freeze action except in very brightly lighted places, a slow film will do as well as a fast one. Try and keep exposure notes so that the next time you shoot at night, you'll have a ready reference.

Photo 7-9: This is the first of four night shots about which I want you to play detective. Questions about technique will not be tricky, and answers should be apparent if you think about relationships between shutter speed, moving subjects, and the results seen in the pictures. In the coming year, I hope you will try each of the pictorial categories in this chapter and more, because you're likely to get pictures you want to hang, project, exhibit, and feel good about. One of the objects of the *Workbook* is to help you get through any hang-ups with techniques, and to encourage you to *try everything* possible with a camera, and afterward, in the darkroom, if you're so inclined.

1. Why is it obvious photo 7-9 was taken from a tripod?

2. What shutter speed was probably used?

Photo 7-10: Detective work on this one may be more difficult, but when you know it was taken at the edge of an airport . . .

1. What caused the jiggle or unevenness in the light streaks along the bottom?

2. There's a faint, almost sharp impression of the airliner's tail, but the nose section is a blur. How can this be explained?

Note: About a dozen such pictures were taken at dusk one day when aircraft landings were plentiful between 5 P.M. and 6 P.M. at Los Angeles International Airport. Some were completely blotched, others were interesting, but none was as simple and graphic as 7-10. Every town and community has an airport; are you anticipating *your* opportunities?

Photo 7-11: Downtown Los Angeles from a nearby hill, taken after dark from a tripod.

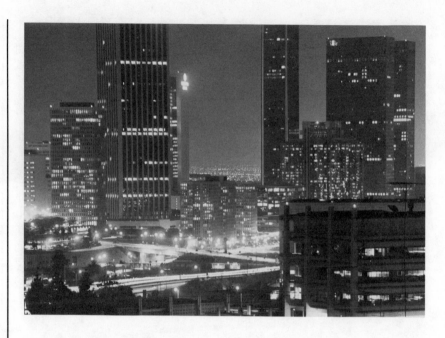

7-11. *Exposure techniques are questioned in the text.*

1. It is obvious that the exposure was longer than 2 or 3 seconds; how can you tell?

2. Why are some of the signs not readable and the sky a dark gray rather than pure black?

7-12. What scattered to make a light pattern so decorative, and how still was the camera?

Photo 7-12: The *Workbook* goes out with a bang.

1. What caused the light streaks, and why are they so wide?

2. If you can't wait until the Fourth of July, where can you go to shoot similar subjects sooner?

Exercises

7-9

Author's responses to questions on experiments at night:

Photo 7-9: 1. Because stationary objects are sharp, while moving cars are blurred. The camera had to be anchored.

2. It isn't easy to guess shutter speed precisely. The blur of cars at right and center indicate 1/2 sec. or 1/4 sec., but they are closer to the camera. Actual exposure was at 1/2 sec. Notice the tone in the sky, which shows it was dusk, not black night.

Photo 7-10: 1. The camera was on a tripod for the 1 second exposure, but it was panned unevenly, and the light streaks echo the camera's jiggle.

7-10

2. The camera was panned from left to right, following the movement of the 727 airliner. Because the camera was motionless for perhaps 1/10 sec. before panning began, though the tail section was moving, a wide, ghostly image of it appeared on film. After the exposure started, the motion of the camera and the plane were out of synch, and the aircraft blurred.

Photo 7-11: 1. Because the foreground lights of cars passing on the freeway have become condensed streaks, it indicates the camera shutter was open more than 5 or 10 seconds—depending on f-stop. Actual exposure was about 15 seconds on ASA 125 film at f/6.3 with an 80–200 mm zoom set at 200 mm.

7-11

2. Each effect is the result of slight overexposure. Another negative made at about 10 seconds shows the lights and signs more distinctly, but there were too few middle tones in the buildings. At 15 seconds, the film collected light glowing faintly in the sky.

7-12

Photo 7-12: 1. The phenomenon is fireworks, as you knew, and there are several ways to photograph them at night. With a camera on a tripod, open the shutter for 1 or 2 seconds between f/8 and f/11 with an ASA 100 or ASA 125 film, and you'll get lovely flaring thin lines, depending on the type of fireworks you shoot. Another method involves a handheld camera set at 1/2 sec. or 1 second. Though you try to hold steady, camera shake makes lines of light wider. Photo 7-12 was taken at 1 second with a handheld SLR which was slightly moved on purpose to thicken the flash lines for decorative effect.

2. If fireworks are legal where you live, you can display them for pictures whenever you wish. Otherwise, experiment with lightning, using the camera on a tripod, and trying to anticipate the flashes. Use a locking cable release to hold the shutter open, set the lens at about f/4 or f/4.5 with ASA 100 or ASA 125 film, and hold your hand or a lenscap over the lens if you don't want the surroundings to register clearly.

CAMERA MOVEMENT TEST

Here's a simple, perfect-circle dot:

Stand the book with this page open in a very shady place, or indoors where you can shoot at between 1/15 sec. and 1/500 sec.

Handholding the camera, and from as close as you can get with a 50 mm lens, shoot a series of exposures directly in front of the dot. Some of the type around the dot will show, but no matter. Make your series at 1/4 sec., 1/8 sec., 1/15 sec., 1/30 sec., 1/60 sec., 1/125 sec., 1/250 sec., and 1/500 sec., or at as many of those speeds as you choose when you know what this is all

about. Use whatever film you like, although color slide film will show results best because you can project your pictures of the dot to larger proportions than you might get in a print. Adjust the light to match the film and shutter speeds, as you like.

Hold your breath as you make exposures, and brace your elbows against your sides, but avoid tension. Use your best technique to steady the camera, but *do not* brace yourself or the camera against any object such as a wall or table.

When the test pictures are developed, project the slides so that the dot appears larger than on the book page. Prints should be 4″ × 5″ or similar size, with the dot enlarged to at least the size it is in the book, and larger if feasible.

Keep a record of your exposures, and arrange prints or slides in the order taken. It will be no surprise to see that the dot is a blurred oval at slow shutter speeds, because you expect camera shake under those conditions. It may be quite surprising to note that the dot is *not* a crisp round circle at higher shutter speeds. Why?

The reason is that image sharpness with a handheld camera is relative. When your hands and your camera synchronize smoothly, real sharpness is possible, and higher shutter speeds usually disguise minor camera shake; but shoot the dot with your camera on a tripod and compare results. Obviously, there's no reason to stop shooting handheld pictures, but it is a good idea to know your human capabilities, so that you'll use a tripod or brace the camera in appropriate circumstances. Working from a tripod also encourages you to compose more carefully. Luck occurs when preparation meets opportunity.

MONITORING YOUR METER

Here are the conditions for making a personal exposure meter test to know better how the meter "sees":

— Choose a 35 mm camera with 35 mm or 50 mm lens, or equivalent medium-format camera. I'm assuming the camera has a built-in meter, since most do today.

— Use black-and-white or indoor color film. Use a conversion filter or a correction filter if necessary.

— You'll need a tripod or clamp to brace the camera.

— Make the test in an average room where there are floor and/or table lamps; ceiling lights are fine, if available, but are not mandatory. The experiment will be more fun if someone is sitting in the room, but an empty area is okay.

— Shoot at night and turn on most or all of the room's lamps. Begin photographing from a corner to include as much of the room as possible. If yours is not a wide-angle lens, or the room is large, photograph it in segments. Raise the camera to eye level on the tripod.

The goal of this experiment is to discover how your meter varies exposure as your lens includes different views of the same room. As you maneuver the camera, for each view shoot at least one frame at the exposure indicated by the meter. Then bracket if you wish, or choose another exposure that's more or less than the meter reading. Keep notes.

Evaluating your pictures. Keep in mind that the meter is averaging the light intensity viewed by your lens, and that it is trying to produce a nice middle gray where neither over- nor underexposure exists. But in a room where the light is neither balanced nor arranged for photographic purposes, the result will be underexposed pools of light or overexposed shadows, or areas that you wish had more or less exposure. People in the scene should sit in the middle distance where lighting is average, for accuracy of skin tones helps you evaluate prints or slides.

From this kind of exercise you will learn how to use your exposure meter more efficiently, and how to trust it. You will also discover that the finest meter and film cannot compensate for lighting that is too contrasty to average by photographic materials that do have limits. Rooms are inconsistently lighted, and this test will (a) add to your confidence about adjusting exposure indoors to emphasize highlights or shadows, depending on the subject; and (b) suggest that floodlights or bounced flash may be needed to improve very uneven lighting.

OVER AND OUT

This book was written and revised during the final typing while I was touring the United States. While most of the black-and-white illustrations were chosen before starting the trip, many of the color photographs were made on the road. I point this out to emphasize that I continue to enjoy photography for fun as well as profit, and I've consistently been involved in most of the basics dealt with in the *Workbook*. In other words, taking pictures is no more academic for me than it is for you. I

126

may have absorbed the techniques about which I've written, so they are more automatic for me than for the average reader, but the excitement of seeing with a camera has never waned.

On that note, I send you out to picture your world, whether it be in your own backyard or in some exotic spot like southern France. There's pleasure in photography everywhere.

* * *

The *Workbook* ends here, but your involvement in photography for fun and satisfaction goes on indefinitely. Good shooting!

Suggested Reading

The Best of Popular Photography. New York, NY: Ziff-Davis Publishing, Co., 1979.

Davis, Phil. *Photography.* New York, NY: Wm. C. Brown Co., 1978.

Eastman Kodak. *The Joy of Photography.* Rochester, NY: Eastman Kodak Co., 1979.

Encyclopedia of Practical Photography. Garden City, NY: Amphoto/Kodak, 1979.

Hedgecoe, John. *The Art of Color Photography.* New York, NY: Alfred A. Knopf, Inc., 1978.

Jacobs, Lou, Jr. *Amphoto Guide to Lighting.* New York, NY: Amphoto, 1979.

———. *Expressive Photography.* New York, NY: Goodyear Publishing Co./Prentice Hall, 1979.

———. *How to Take Great Pictures With Your SLR.* Tucson, Ariz.: H P Books, 1978.

———. *Photography Today.* New York, NY: Goodyear Publishing Co./Prentice Hall, 1979.

Levey, Marc, Margaret Irish, and Samuel Kazdan. *Photography: Composition, Color, Display.* New York, NY: Amphoto, 1979.

Life Library of Photography. New York, NY: Time-Life Books, 1979.

Nibbelink, Don and Monica. *Picturing the Times of Your Life.* New York, NY: Kodak/Amphoto, 1980.